HOW TO MAKE
WATERCOLOR WORK
FOR YOU

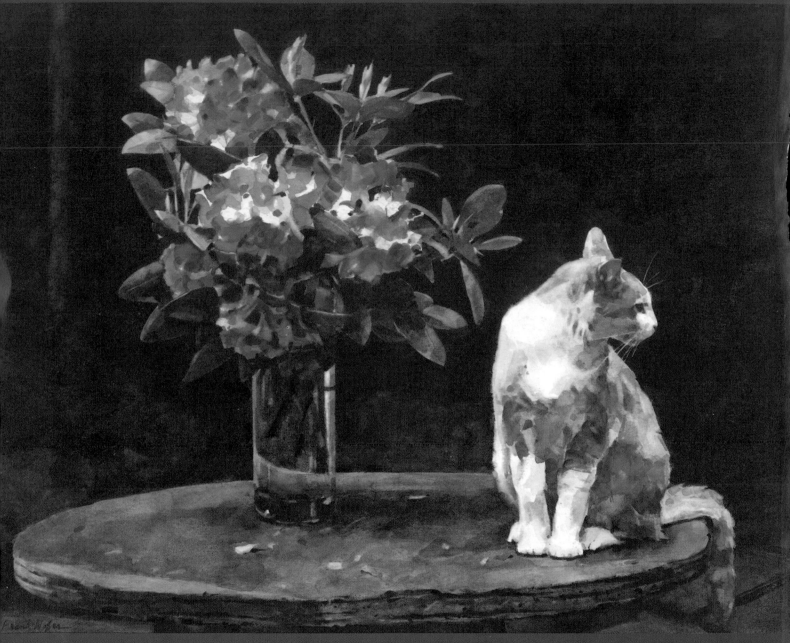

My original intention was to paint a rhododendron still life. However, Nutmeg, our cat, thought his presence would enhance the composition. I agreed and included him in my watercolor.

HOW TO
MAKE
WATERCOLOR
WORK
FOR YOU

FRANK NOFER

NORTH
LIGHT
BOOKS

Cincinnati, Ohio

95 94 93 92 91 5 4 3 2 1

Library of Congress Cataloging in Publication Data

Nofer, Frank
 How to make watercolor work for you / Frank Nofer. — 1st ed.
 p. cm.
 Includes index.
 ISBN 0-89134-379-2
 1. Watercolor painting—Technique. I. Title.
ND2420.N64 1991
751.42'2—dc20 90-28125
 CIP

Edited by *Greg Albert and Rachel Wolf*

This was my first exposure to a horse show. The colorful activities, the riders' habits, and the imposing animals evidenced paintable subject matter at every turn. This watercolor was my initial effort. Several other horse show paintings appear throughout this book.

THE REDCOATS ARE COMING, 17½″ × 14½″, courtesy of Newman Galleries

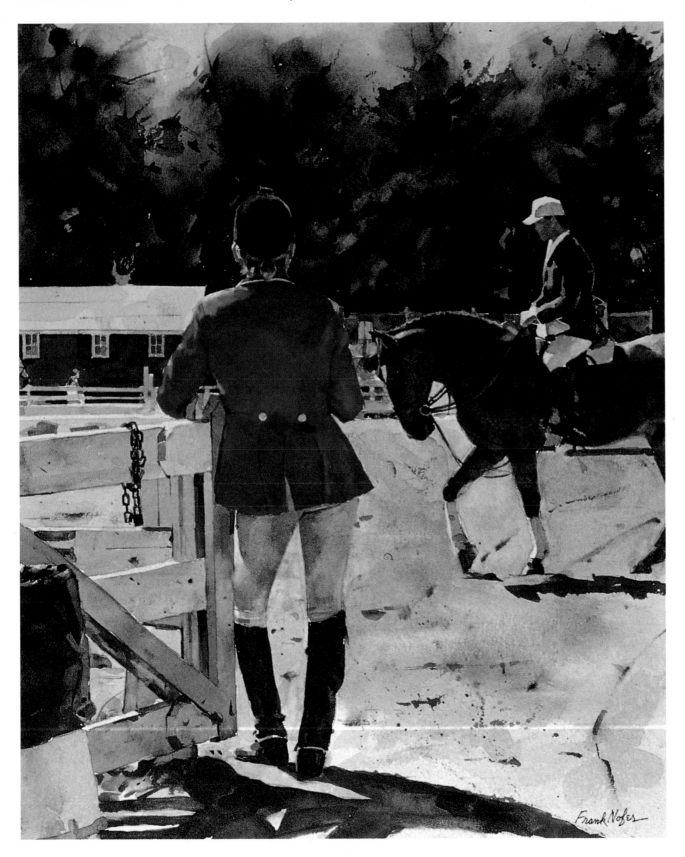

Dedication

To my wife Dorothy and our children, Kristin and Frank

SCARLET SENTINEL, 10″ × 14″, private collection

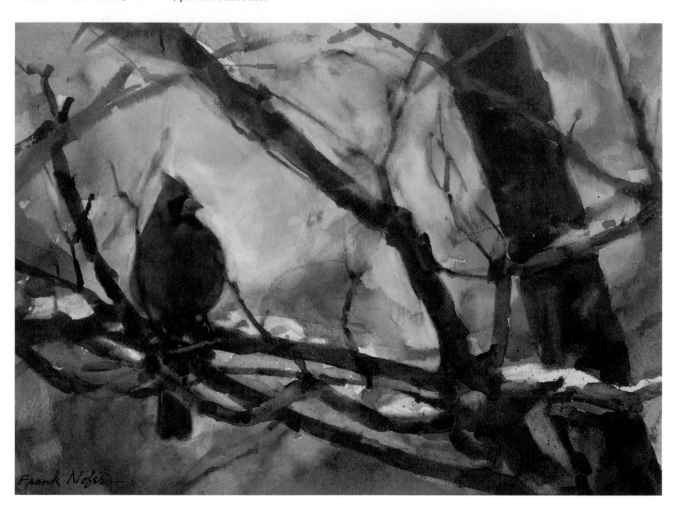

The common birds which frequent our
suburban property are a constant joy.
I just wish they would sit still longer and
give this artist a break.

LATE DAY BLUEJAY, 8½″×11″, courtesy of Newman Galleries

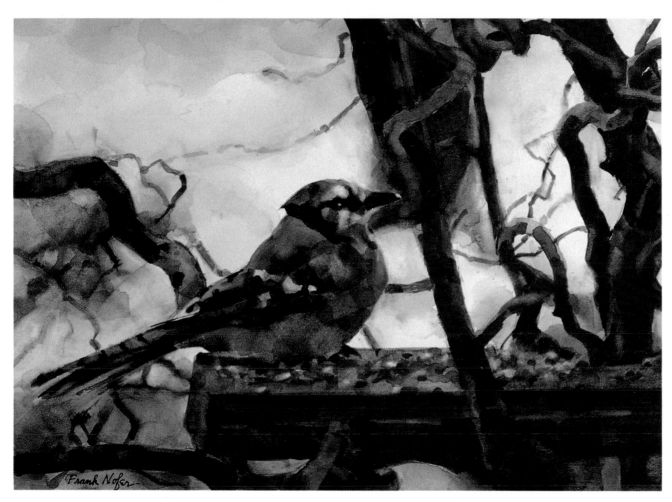

In midday flight the sun highlights a bluejay's colorful plumage. However, as dusk approaches, announcing "last call for dinner," he presents a more muted image. I tried to capture this feeling of evening quietude.

Acknowledgments

Charles B. McCann — my high school art teacher. Throughout our four year association he was demanding of me and short on praise. However, upon my graduation, his recommendation resulted in my being granted a full tuition scholarship to the Philadelphia University of the Arts.

W. Emerton Heitland — my college art professor and a distinguished illustrator and watercolorist. I know many of today's watercolorists who can trace their success to his inspirational teaching. I feel privileged to have won the first prize given in his memory.

Maurice Molarsky — principally an oil painter of the Singer Sargent school with whom I studied privately. He stressed form and simplification and his advice, "Use the largest brush possible in any given area," was worth the price of all the lessons.

Warren Blair — my neighbor, former Design Director of Smithkline Beckman and a "fine artist." We serve as sounding boards for each other's work.

Rosa Pronesti — a principal in the graphic design firm I headed for twenty-five years and a fellow watercolorist. She helped me in ways too numerous to mention as I put this book together.

Greg Albert — Editor, North Light Books and coordinator of this entire project. Any author would be fortunate to have a pro like Greg, together with his associate, **Rachel Wolf**, to keep him on track.

HOMEWARD BOUND, 21" × 27", private collection

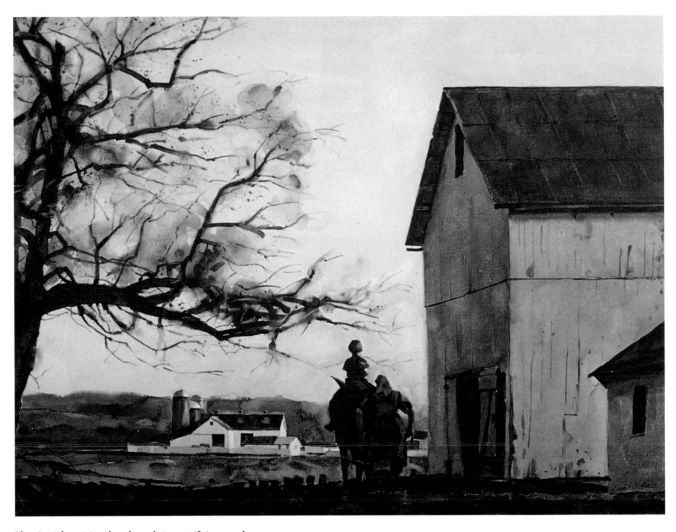

The Amish spirit — hard work is gratifying work.

Contents

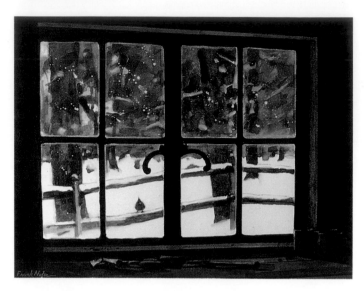

DECEMBER FLURRIES, 12″ × 15″, collection of Ann Castelan

PART THREE

Forgiveness: Watercolor's Best Kept Secret

Discover effective techniques for correcting ten common watercolor problems

PART FOUR

Photosketching: Use Photography Creatively

Find how you can use your camera to make more exciting paintings

PART FIVE

Ten Commandments for the Watercolorist

Remember these guidelines to keep you on the path to success

Introduction

I invite you to join me in accepting the challenge of watercolor.

Someone once stated that, "For every knotty problem, there is a simplistic solution—neat, plausible and wrong." Watercolor is abundant with knotty problems and there are no simple answers. But I say this is good news. As a creative person, the artist welcomes challenge and should be content to leave easy endeavors to the unimaginative. To me, the gratification derived from producing a successful watercolor far outweighs the struggle necessary to handle this elusive medium. Mastering a few simple technical tricks won't do the job. Therefore, let's think in terms of achieving a whole series of small triumphs which will build a solid foundation for producing "winning" watercolors. At the same time I think you will find that this approach to our watercolor adventure will provide added excitement along the pathway from concept to sparkling conclusion.

This book will concentrate on painting representational transparent watercolors with self-assurance. It will stress the need for appropriate planning and conceptualizing which should precede the actual design of the watercolor and application of paint. It will introduce into the artist's thinking the way the eye perceives, a most important yet little understood phenomenon that is the basis for personal interpretation of any given subject matter.

There will be an expansive section intended to encourage the artist to comprehend the "why" behind the time honored rules of watercolor and how to break those rules to achieve more expressive paintings.

The actual watercolor reproductions, together with accompanying discussion and explanation, will present transparent watercolor as a more "forgiving" medium than most suspect. How to "work over a watercolor without it appearing overworked" will be thoroughly examined and supported by demon-

strations of techniques for lifting paint, manipulating hard edges, laying multiple washes, enriching muddy areas, scrubbing, erasing, and isolating sections with frisket material, all while keeping the painting fresh. These techniques can not only be employed to correct or sometimes salvage paintings that have gone astray, but can be used in a predictable way to add new dimensions to the artist's work. However, there will be a ''wrist slapping'' admonition that the artist should not be seduced by the acquisition of technical skills alone. Personal concept and design, even in representational painting, remain the building blocks of successful watercolors.

For those who enjoy the ''thrill of the hunt'' we'll explore how to flush out compositions where no paintable subject matter seems apparent. The book will also address ''what is realism'' and hit head-on the pros and cons of the much debated subject of photographic assistance in painting.

Within the framework of starting a watercolor with both a plan and a mental image to keep the artist on track throughout the development process, there will be many intriguing subcategories, which a brief review of the Table of Contents will reveal. And, at times, some salient points will be readdressed throughout the book, because they warrant repetition or because they play multiple roles in the seeing and painting process.

It is not my intention to tempt the reader to paint my way. Rather, I hope the book will prove instructive, thought provoking and challenging. And, most important, I hope it will inspire you to paint your way with a new-found conviction and sense of enjoyment.

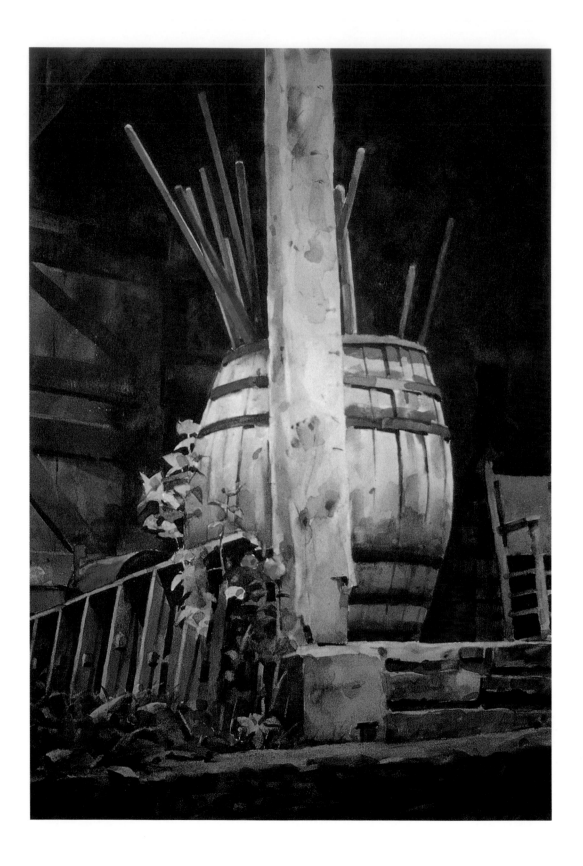

PART ONE

SEEING
Paint as Your Eye Perceives

Splitting the composition right down the
center with a rough hewn timber is strictly
taboo. But breaking the rules occasionally
is fun, especially if you get away with it . . .
Rain Barrel, 20″ × 13¾″, collection of
Elizabeth Seiberling

How the Eye Perceives

How the eye *sees*—the actual physiology of human sight—is best understood and explained by an ophthalmologist. But how the eye *perceives* is a matter for the artist. It involves the unique way in which we recognize space, read detail, scan our surroundings, and understand the subtle tricks that light plays on us. It's the visual phenomenon we must thoroughly understand in order to paint most effectively.

Simply put, the basic challenge of painting is to translate the three-dimensional world onto the two-dimensional surface of paper or canvas. And I'm most interested in painting the way we actually see—to somehow capture the experience of human vision. I believe the following tips on visual perception will provide you with creative options rather than compromises based on the limitations of your flat canvas or paper. Although this book is about representational watercolor, I think you will find these observations helpful for working in any medium (or style) you choose.

When viewing three-dimensional subject matter, the human eye has limited depth- and breadth-of-field perception. That is, it cannot keep the foreground, middle ground and background in focus at the same instant, nor can it include a wide expanse of subject matter.

Unlike a still camera, which can record extensive depth- and breadth-of-field on film, the human eye constantly scans, moving its focus from one area of interest to another, thereby accumulating a series of mini-images which it then assembles into a complete picture.

In fact, television and motion-picture producers accommodate the human eye's penchant for motion. The next time you "fix focus" on a TV screen, you might notice that the TV camera is doing the scanning for you—moving, shifting, panning and focusing on detail much the way your eyes normally do.

I conjured up this rather rough pen-and-ink sketch of a landscape with horses to illustrate the difference between camera and human vision. The red circle indicates how a camera takes in everything in one gulp without discrimination.

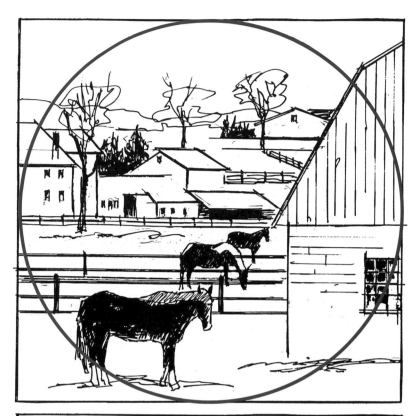

Unlike a camera, the human eye chooses a pathway of visual stopping points as it scans any given subject matter. It then quickly puts together the pieces and completes the puzzle. The red bullets suggest the visual route my eyes might take. Your eyes would probably select a different visual pathway and assign priorities to elements of the picture which I dismissed. And therein lies the opportunity for personal interpretation as we paint.

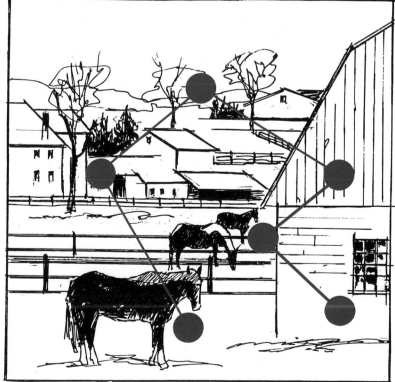

Bearing in mind the limited depth- and breadth-of-field capability of the human eye and its relentless propensity for scanning, I usually consider the following five options in the initial stages of a painting.

1. I dismiss the idea of painting all areas of the picture in sharp focus. Instead, I prefer to capture the phenomenon of human perception rather than that of a still camera.

2. I evaluate whether the foreground, middle ground or background presents the greatest visual interest. Then, I zero in on that area of the painting and subordinate the rest of the picture to it.

3. Most frequently, I scan the subject matter and try to lead the viewer through my painting by determining a well-designed pathway paced with visual stopping points.

4. At times I consider a combination of options two and three above. First, I'll choose an area for first-priority visual development. Then, through the introduction of limited detail, contrast or special color, I'll accent other small areas of the painting. But it's most important that these additional areas of attention be well patterned and appropriately support the main statement of the work.

5. Occasionally, the arrangement of shapes and colors is so exciting that a two-dimensional surface translation of the subject matter is the best interpretive choice. The paintings of Picasso, Matisse and the later work of Milton Avery can hardly be called realistic, but their legacy of consummate surface composition should be recorded in every painter's genes. Even with a predominantly "flat" surface design you can control how the viewer scans your painting with the use of selective detail, color intensity, and size and arrangement of shapes.

I started to paint the distant farm buildings but kept stumbling visually over the yellow dandelions right before my eyes. It then dawned on me that concentrating on the yellow patterned foreground was a more exciting option. So the farmhouse, barn and silo were relegated to "soft focus status" and the dandelions became the dominant theme of the watercolor.

OHIO DANDELIONS, 16″ × 27″, collection of Mr. and Mrs. George Nofer

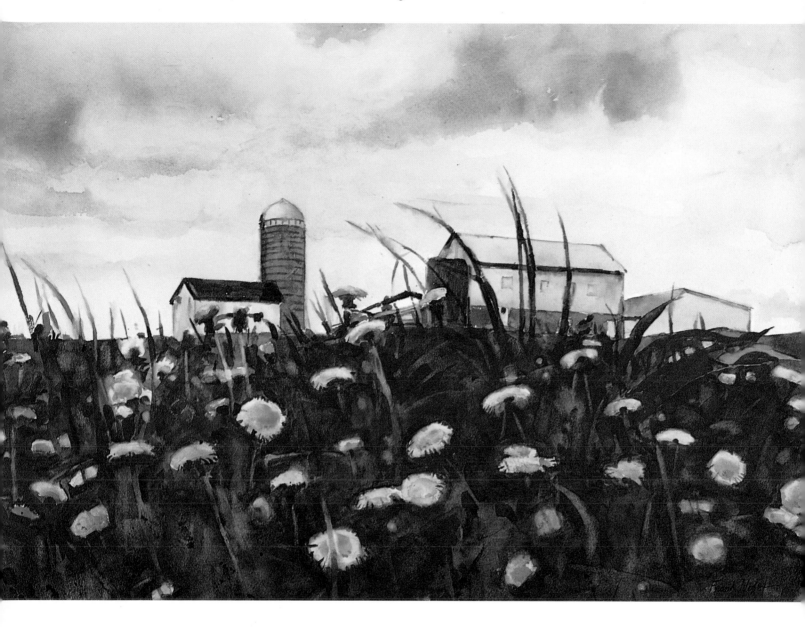

Should detail wag the dog? Having established that the human eye scans and moves its focus from one area of interest to another, I will now add that it is only at those periods of focus that the eye concentrates on detail.

Detailing is a basic technique for creating stopping points, and thus leading the viewer along your chosen path. But I believe a little detail goes a long way. One of my first instructors once told me, "When you paint a bunch of grapes, paint the form of the whole and then highlight three individual grapes. The eye will do the rest." Inviting the onlooker to participate in the completion of your painting furthers his personal involvement and, in a sense, makes him a coauthor of the work.

"The hair and feather school." However, another school of thought differs in opinion. Some artists pride themselves in detailing every square inch of their paintings. This "super realism" goes beyond how the eye actually sees, and requires exquisite balancing of all detail to avoid overkill. But if successfully executed, it proves fascinating to those who are enamored of meticulous craftsmanship. I don't choose to paint this way, but . . . different strokes for different folks.

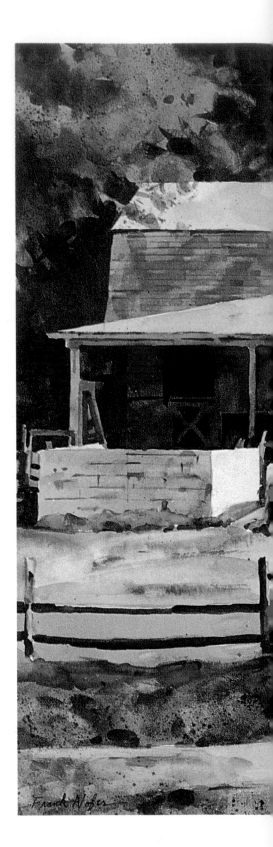

This painting was pronounced complete until it became apparent that the activity of the foreground and background was challenging the middle ground, which is the main focus of the painting. Sponging the foreground out of critical focus and laying washes over the background simplified and enhanced the painting. But I admonished myself for having to undo a lot of nice detailing to make the painting work.

ANDORRA HORSE FARM, 21½″ × 27½″, private collection

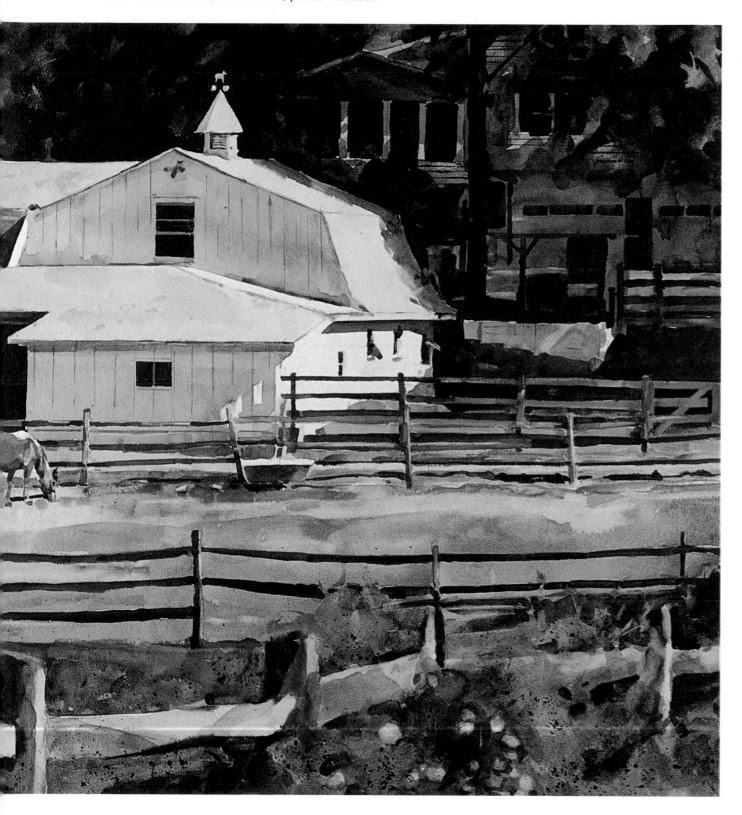

LATE BLOOMERS, 17¼″ × 26¾″, collection of Mr. and Mrs. George Nofer

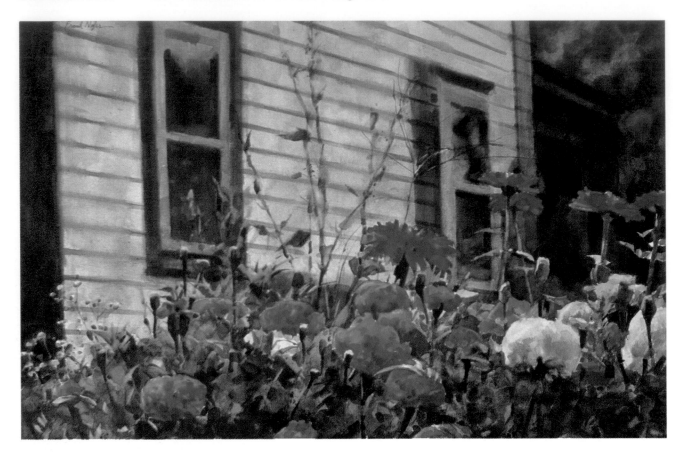

When I started *Late Bloomers* I immediately wanted to establish visual intimacy with the flowers in the foreground. Therefore, I took advantage of the human eye's limited depth-of-field capability, painted the flowers in sharp focus and softened the clapboard farmhouse so it merely added depth rather than content to the picture. Unlike most of my work, this watercolor came rather easily. I had more trouble naming it than I did painting it.

YELLOW AWNING, 15¼" × 20¼", private collection

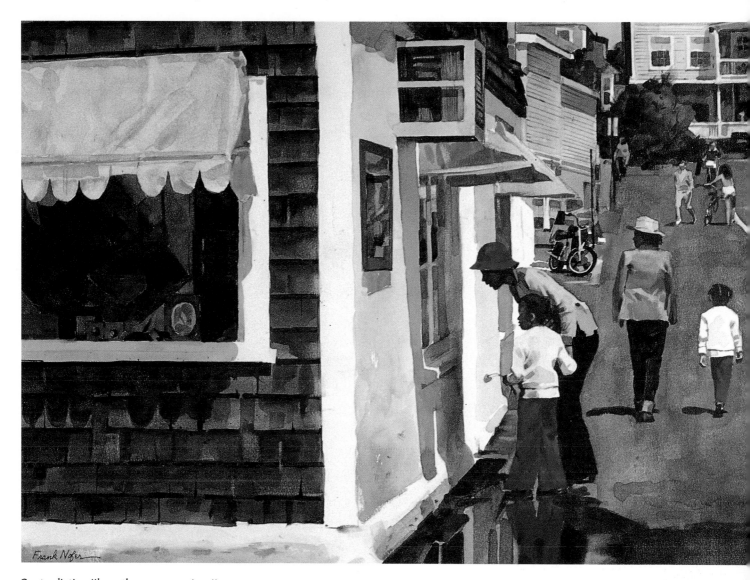

Contradicting "how the eye perceives" this painting equally delineates foreground, middle ground and background. It may appear somewhat photographic; however, unlike a camera, I established a sequential pattern of stopping points to lead the viewer through the watercolor my way. I ask you not to linger to window shop under the yellow awning, but to observe the shoppers and then follow the distant figures up the road.

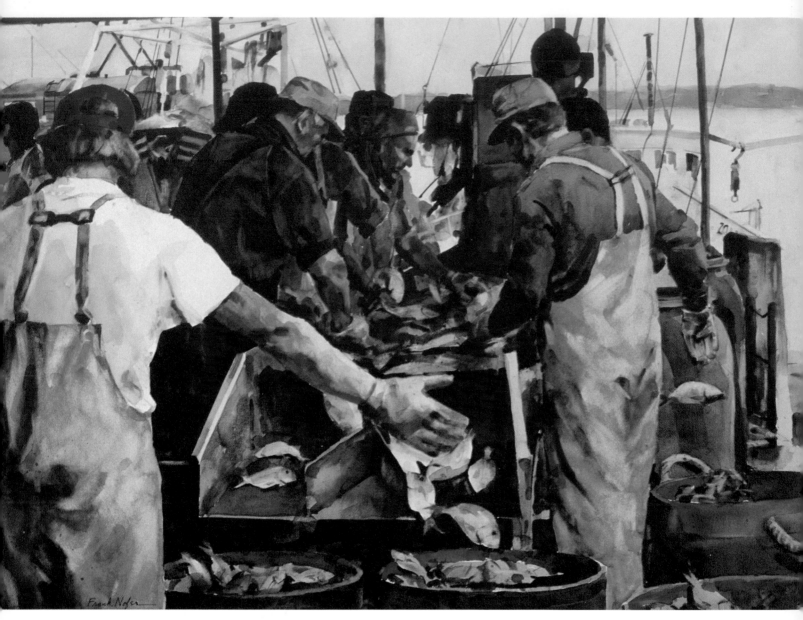

In this painting I wanted the viewer to take the time to examine each figure at his task. Hence, the fisherman in the foreground immediately slows your visual progress with his outstretched arm. Then the viewer is free to move through the watercolor at my predetermined pace.

The reader may be amused to know that every fish in this painting is the same fish. When I painted the watercolor, the entire catch had not been unloaded and actual fish were in short supply. I bought one porgy at the local fish market and sketched it in every conceivable position to create the entire fish population.

Winter's Chill is basically a surface painting. It is essentially an arrangement of foreground shapes. Other than the smaller birds, there is no attempt made to establish the illusion of physical depth. It is a representational watercolor even though a two-dimensional pattern determines the success of the work.

SPRINGHOUSE AND DAY LILIES, 16¼″ × 21¾″, collection of Mr. Richard S. Tobey, Jr.

Bold, flat geometric shapes comprise the substance of this work. The fact that the elements are recognizable has less to do with the success of the painting than do the design, color and texture.

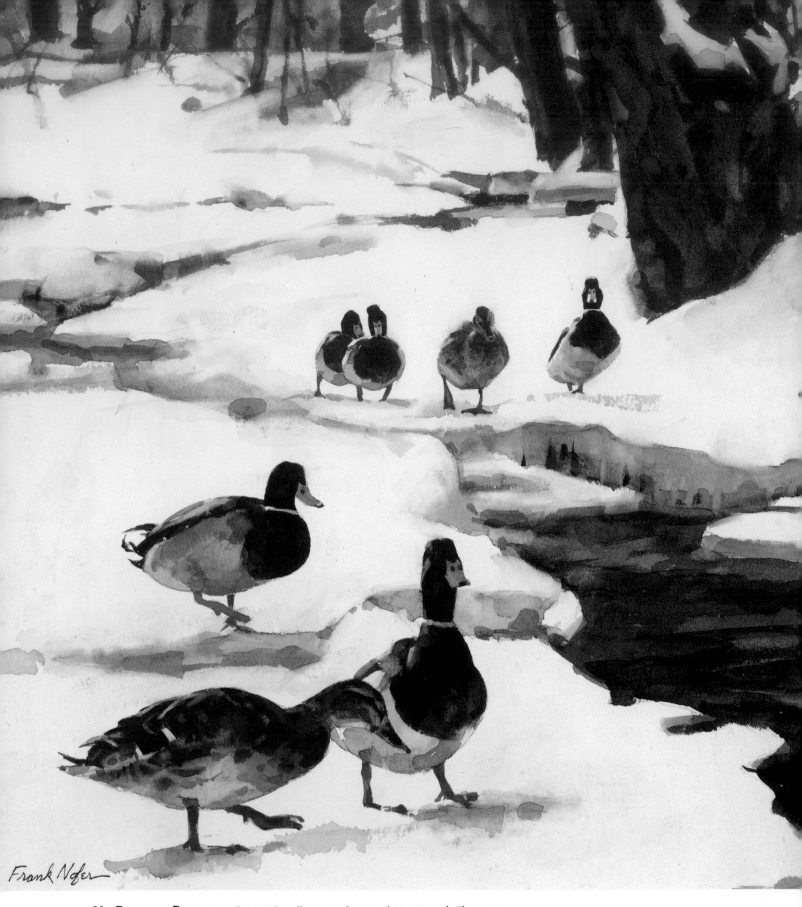

NO ROOM TO PADDLE, *18″ × 25⅝″*, collection of Mr. and Mrs. Joseph Flanagan

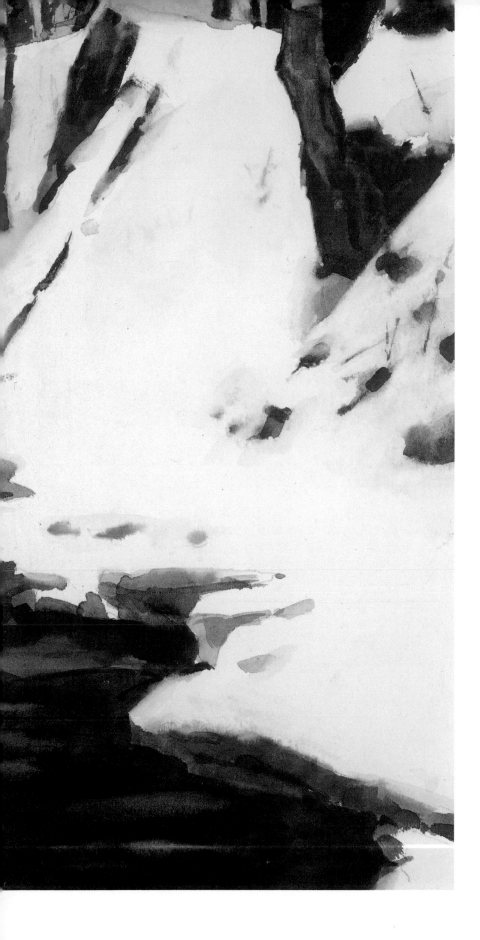

Mallard ducks looking for a place to swim in this snow blanketed environment is the story of this painting. I could have detailed every feather, but then it would be an ornithological study and not an interpretive watercolor. This painting appeared later as a Christmas card and limited edition print.

Simplify by Squinting

If I were limited to one word of advice about painting, I would say *squint*. Squinting simplifies your subject and eliminates meaningless detail. For instance, since squinting enables you to identify the important masses of your subject matter, it makes the translation of several miles of landscape to just a few square feet of your working surface an easier endeavor. Even when you're painting an object actual size, squinting allows you to find a more simplified interpretation of your subject. And when working at arm's length from your subject, squinting will show you approximately how your painting will appear at a normal viewing distance, say six to ten feet from your finished work.

Open-eyed naïveté will tempt you to paint leaves and trees — squinting will help you see the forest as an overall simplified shape.

I don't mean to suggest that you go through life with your eyes half closed, rather that you use the squinting technique as a safeguard against a natural tendency to overcomplicate.

Since this reproduction is close to the actual size of the original painting, it presents an opportunity to experience one of the benefits of squinting. If you squint at the portrait from reading distance, about 14 inches, you can tell how it will look at normal viewing range. Try this in your own work and save yourself some footsteps . . . **Marie Elena**, 12″ × 9½″, private collection

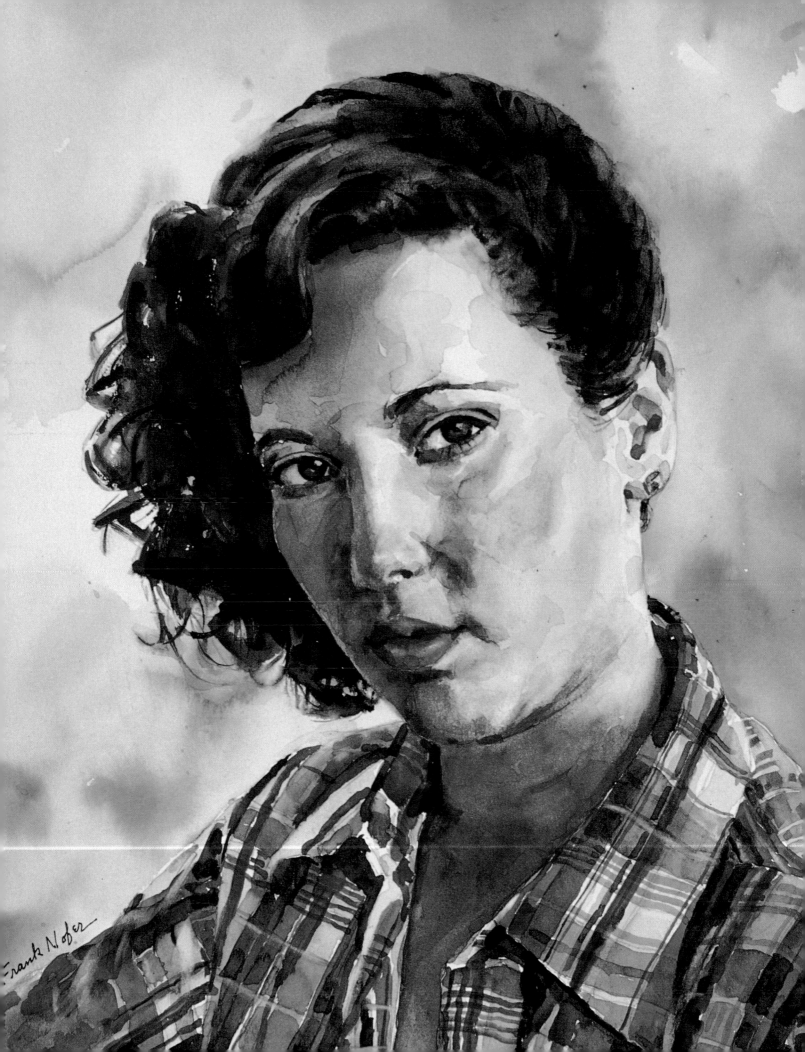

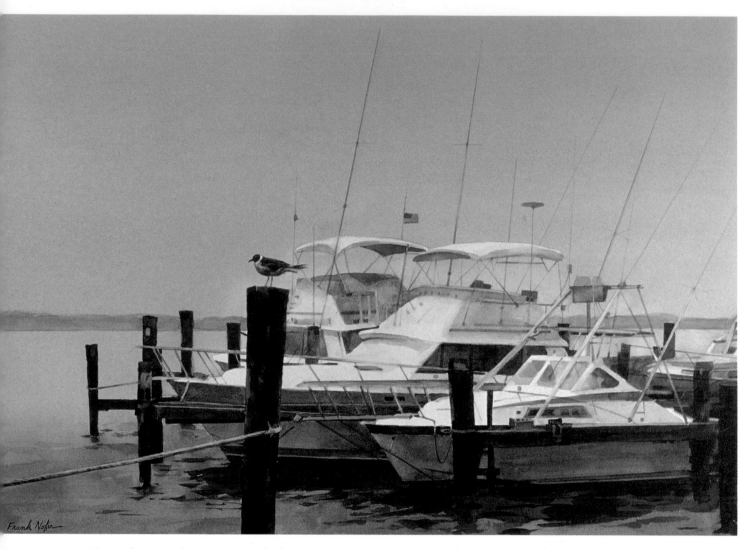

MARGATE TIE-UP, 18″ × 26½″, collection of Carolyn C. Smith

The reader may ask what squinting had to do with this painting. The watercolor is busy with boats, ropes and rigging—and it should be. But squinting allowed me to reduce extraneous detail to a point where it was a meaningful component of the picture and not an overwhelming network of spaghetti.

A ROSE IS A ROSE . . . , 10¼″ × 12½″, collection of Mr. And Mrs. David Wurtzer

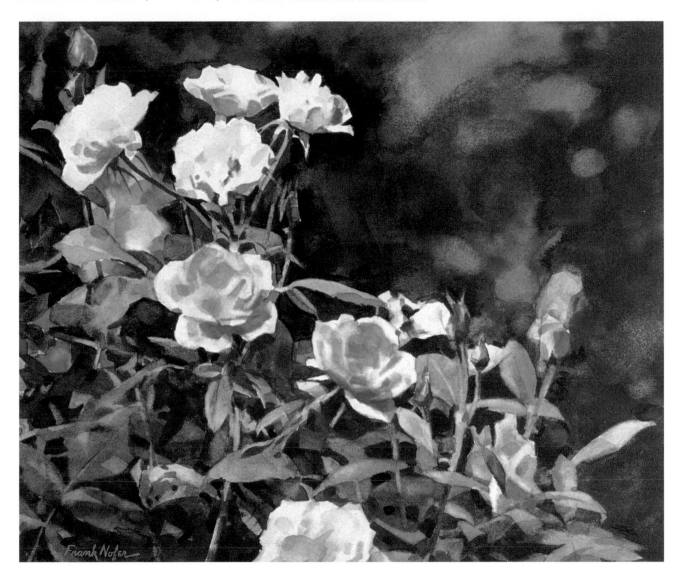

Unlike a daisy whose flat white petals and yellow center tell the story, the rose is one of the most difficult flowers to paint. When in bloom, it has a subtle labyrinth-like inner structure similar to the human ear. If the artist delineates this form within form too definitively the flower loses its softness. On the other hand, if he fakes the form and relies on shape, he will invent a generic flower. Here's where squinting comes in. It prevents overkill or understatement in the delicate structuring of this beautiful flower.

Light Reveals,
Shadow Conceals

This often-quoted axiom is neat and plausible, but it's only half right. The real question for the artist is how the human eye perceives light and shadow when both play dominant roles in the subject matter we choose to paint.

In general, soft diffused light reveals detail, form and color throughout the composition. Sharp, cast shadows are absent, and the intrinsic tone and hue of each component of the picture stands out. But what if you're painting a scene in stronger light?

Well, bright, single-source illumination usually results in a dramatic pattern of light and shade. In this case, it's true that "light reveals and shadow conceals." If you permit your eye its predisposition to gravitate toward the light, then detail, structure and color will be discernible in the brightly illuminated areas, and the shadows will read as darkened voids. At times, this dark-and-light pattern is stimulating and can form the basis for a sound painting.

But here's the other side of the coin: If you peer into the dark areas long enough, your pupils will dilate and you will discover intriguing color, detail and form within the dense shadows. Now the circumstances are reversed, and that well-known axiom changes to this: "Shadow reveals and light bleaches." In the brightly illuminated or bleached areas, edges will break down and color and form will fuse. There's room for interpretation in your painting, but you can't have it both ways.

Neither the human eye nor the camera can investigate light and shadow at the same time without compromising the total lighting effect.

So choose to develop the light areas *or* dark areas—but not both—with color and detail.

Single-source direct illumination establishes parity between the cast shadows and the dimensional elements of the painting. Compositionally, the shadows are an integral part of the picture. This watercolor is also a classic example of "light reveals, shadow conceals." I wonder if any keen observers noticed that I invoked artistic license and eliminated any visually competing cast shadows of the birds.

Soft, diffused light means no cast shadows to work for or against you. Individual colors hold their own as separate hues and are predominantly flat. As far as manipulating or moving elements to improve composition, this lighting condition offers the greatest flexibility.

WINTER SHADOWS, 11⅝″ × 13⅜″, collection of Mrs. Paul Morgenthaler

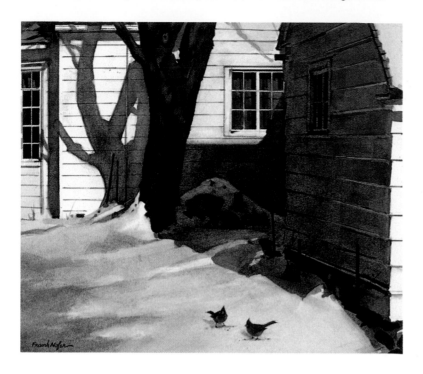

THREE'S COMPANY, 9½″ × 18¼″, collection of Charles Frederick

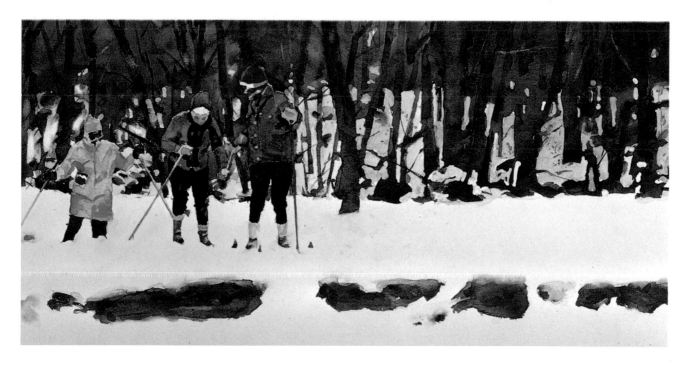

I regard this watercolor as one of my favorites. Light certainly reveals the girls, and shadow conceals the details, but not the abstract shapes of buggies and barn. I particularly enjoyed the challenge of keeping the bicycle at left readable, but still within the shadow plane . . . **Double Dutch**, 16¾″ × 24″, collection of Mr. and Mrs. Carl Shaifer

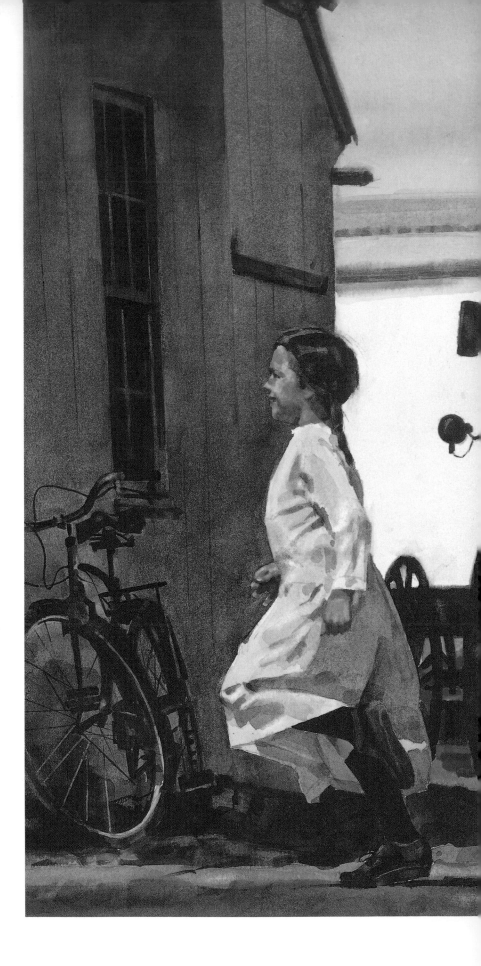

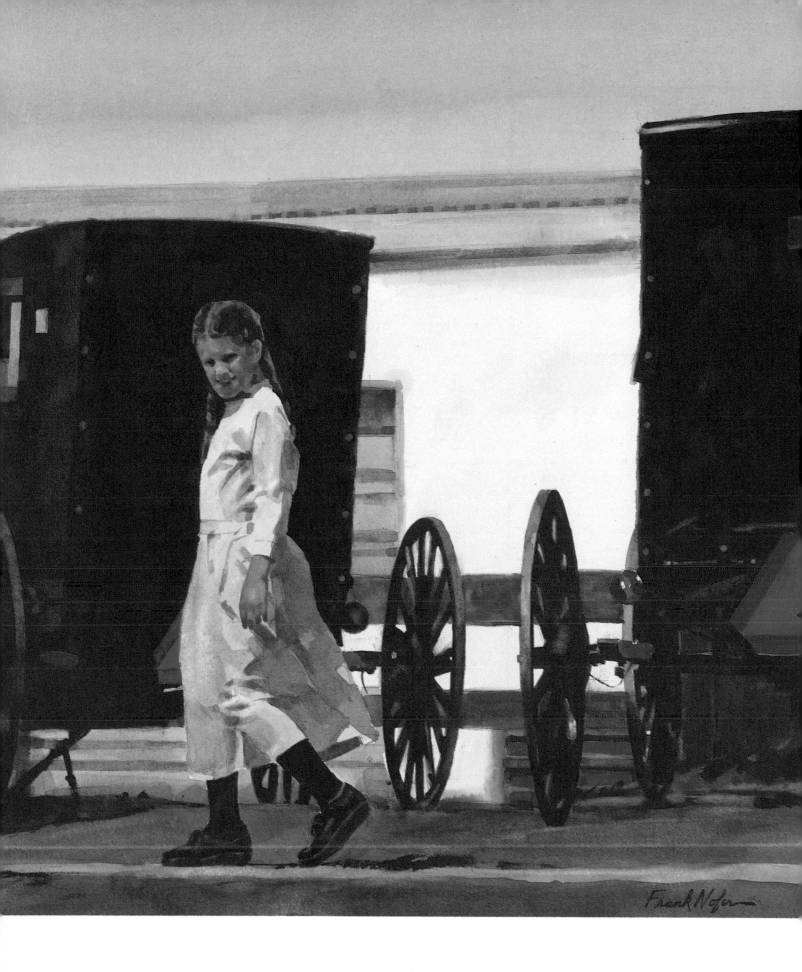

Understanding Depth

Most of us are programmed to focus on people, activities and objects that are relatively close at hand. But true distance viewing—hundreds of yards to several miles—is a more infrequent exercise. Therefore, this everyday myopia translates into "distance means out of focus." Hence, painting distant objects out of focus is one of the most helpful techniques for giving your work depth. But there are four other aspects of depth perception that are just as helpful to the artist:

Perspective. Since perspective is a topic unto itself, I'll just touch on two basic ideas to keep in mind. One, from a fixed point of view, all parallel receding planes appear to the eye to converge at a vanishing point (single-point perspective). Just stand in the middle of straight railroad tracks (minus the train) to see how the rails meet at a distant point. In reality, however, all receding planes are not parallel, and, therefore, multiple vanishing points occur. Determining accurate perspective then becomes more a problem of geometry. But just keep in mind the way planes in space appear to converge. Two, though we all realize that perspective makes objects appear smaller as distance increases, it is important to remember that it does so *in an orderly, predictable way*.

If you are repositioning objects or combining elements from different settings in your painting, then the principles of perspective must be applied. But if you are recording your subject exactly as nature presents it, good draftsmanship alone can keep you out of trouble.

Knowns and Unknowns. In fact, one helpful way to get beyond schoolbook perspective is to relate "knowns" to "unknowns." The system works something like this: If you observe a normal-size man three street corners away, you know two things—the man is about 6 feet tall and (since city blocks are about 100 yards long) he is about 900 feet away. Now, just relate all of the "unknown" objects in that vicinity to the figure in terms of size and distance. For instance, if you choose to move a nearby parking meter and position it next to the man, you can easily figure how tall and wide the meter should be in relation to the size of the man. It might rise to the height of his chest and be about a third the thickness of his leg. In almost every scene you can find animals, fences, trees, vehicles, flowers or even parts of the human anatomy that are "knowns." Draw other objects in relation to these and you can customize a picture with accurate distance and size relationships without the use of formal perspective.

The illusion of distance hardly needs explanation. The gull is in critical focus and the background is nebulous and out of focus. However, I did suggest a hint of middle ground activity by introducing a few gulls on the wing . . . **Gull on Guard**, 13½″ × 19⅝″, collection of Anne D. Emmons

In *Larkin's Farm* the two white fences seek their respective vanishing points, and as they recede the illusion of depth is created. This watercolor comes close to a formal depiction of perspective . . . **Larkin's Farm**, 17⅞″ × 26″, collection of Dr. and Mrs. Donald Kelso

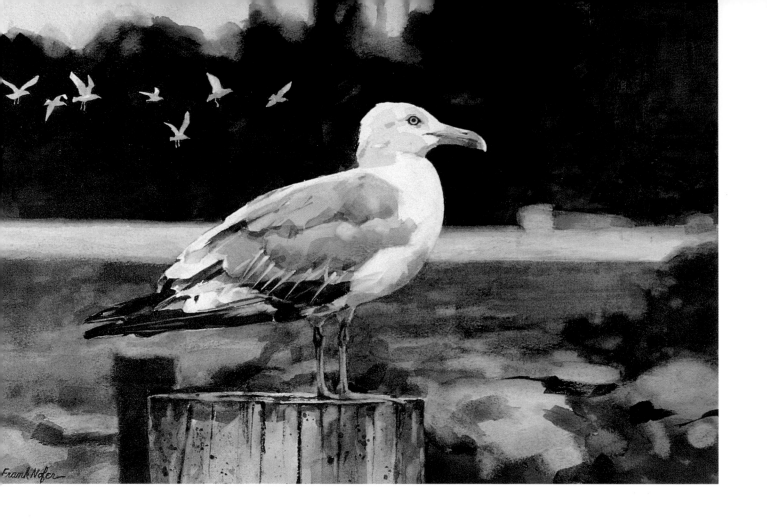

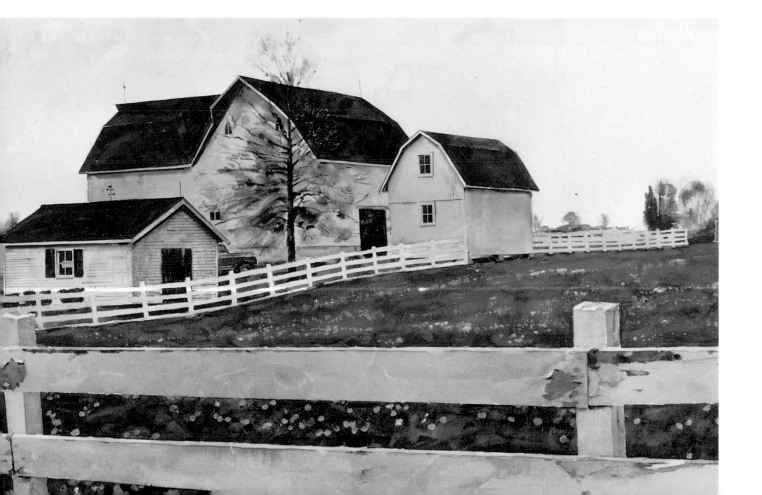

Overlapping. If one object extends over or partially obscures a second object, it is obvious that the former is closer to you. This may sound elementary, but purposeful overlapping is a great aid to the artist in layering distance into a painting.

Let's analyze a hypothetical farm scene. A cow stands in front of a tree, which overlaps a barn, which partially obscures a corn field, which blots out a section of a mountain, which covers half a setting sun. Without further technique, a succession of six receding planes has been established that even the most unsophisticated eye can discern.

Color Connotations. With few exceptions, such as a large, backlit building, truly distant subject matter takes on a bluish cast. Mountains, skylines, bridges and forests all become progressively more blue as greater amounts of atmosphere occupy the void between the viewer and the distant vista. The edges of distant subjects also tend to soften.

As humans, we perceive the world in our own unique way. The greatest distances and the smallest objects are obscured from our range of vision, which differs greatly from other living forms. The honey bee, for instance, sees only ultraviolet light, which makes a daisy take on values and shapes that we could never see with the naked eye. But as an artist, I set my sights on painting the way the *human* eye perceives.

The achievement of depth for depth's sake makes no valid contribution to this painting. However, keeping the trees soft yet identifiable provides a believable distant backdrop which adds to the commanding presence of the crisply delineated pheasant . . . **His Majesty**, 18¼″ × 26″, collection of Mr. and Mrs. Donald Van Roden

Perspective, overlapping of elements, and the relationship of ''known'' to ''unknowns'' (as described in the text) all join forces in charting a three-dimensional visual pathway for the viewer . . . **St. Peter's Village**, 19″ × 24″, private collection

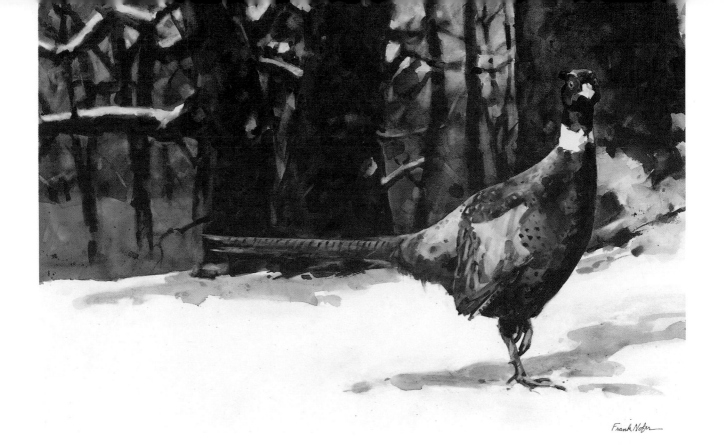

Frank Nofer

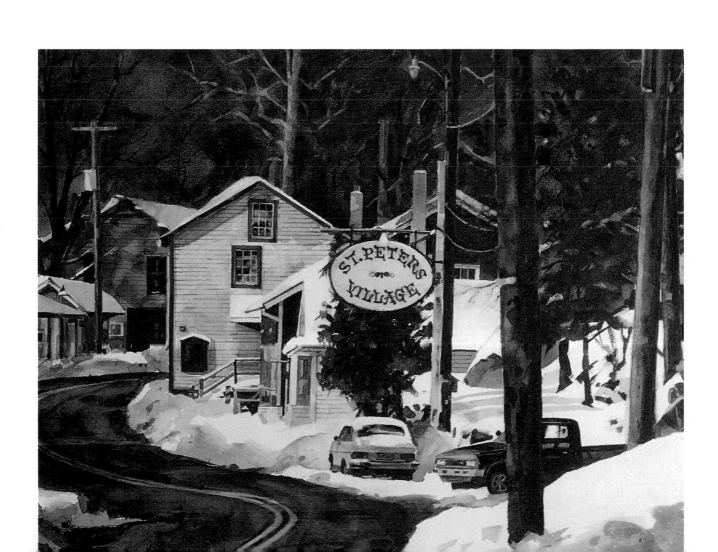

EARLY HITS, 18″ × 25″, collection of Doris Pyle

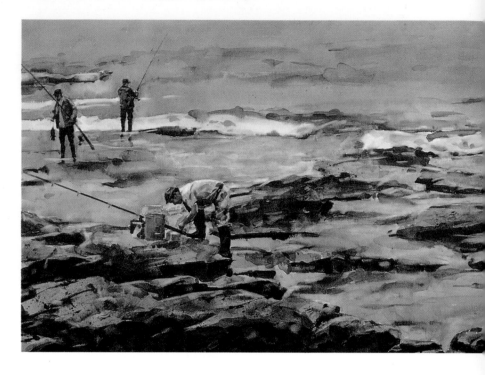

I think it is apparent why this painting conveys a sense of indeterminate distance. Perhaps another lesson to be learned from *Early Hits* is the major contribution depth can make in establishing mood.

FARMS, FARMS, FARMS, 18″ × 26″, collection of David Atkinson

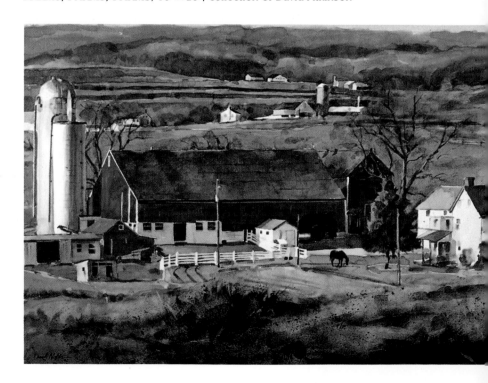

The foreground has form but minimum detail. Therefore, the viewer is drawn to the middle ground where most of the interesting activity takes place. Depth is achieved in this painting largely through a ''step and repeat'' pattern of one distant farm layered on top of another. In reality, the respective farm buildings are approximately the same size. Since the watercolor depicts them as smaller and smaller, the mind says they must be farther away. Also, notice the attention to scale relationship in the middle ground.

PART TWO

VISUALIZING
Get a Head Start

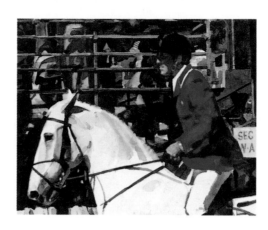

Draftsmanship—
A Prerequisite

Most people think of a draftsman as an individual who sits at a table with T-square, angles and sharp pencils and plots out architectural or engineering schematics. However, in the art context of this book "draftsmanship" means drawing—the ability to depict actual subject matter (usually in linear form) on a flat surface.

As a representational watercolorist you must be reasonably skilled at drawing or you won't know where to put the paint.

Most of the established masters of nonrepresentational painting initially proved themselves as sound academic draftsmen. The ability to trace photographs does not qualify you as a draftsman—sooner or later you'll be headed for trouble.

This book is not a drawing manual—that's another whole book in itself. I feel comfortable that the majority of the readers can draw and the important role of good draftsmanship will be stressed throughout.

It would be unfair, however, to leave adrift any readers whose drawing skills are lacking or need upgrading. Hence, here are some suggestions:

1. Check out art book stores for instructional books on drawing, such as Bert Dodson's *Keys to Drawing*. If the book you consider purchasing does not stress practice, practice, practice, then don't buy it.

2. Seek out and attend a local art school that offers supervised live model, still-life and cast drawing classes—either on a daytime or evening basis.

3. Carry a sketchbook and pencils whenever possible and draw anything and everything that strikes your fancy. Attempt both quick studies and more comprehensive ones—but draw, draw, draw!

4. I touched on perspective in the earlier chapter "Understanding Depth." However, you should probably invest in a book devoted entirely to the fundamentals of perspective, such as Phil Metzger's workbooks, *Perspective without Pain*. Eventually, incorporation of this aspect of receding distance should become second nature when you draw.

WHERE'D THAT SAND CRAB GO?, 11⅛″ × 13¾″, collection of the artist

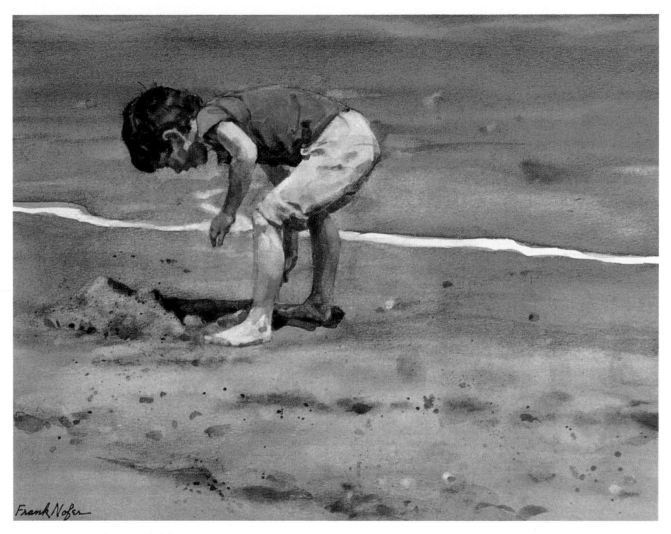

In representational painting, if the artist is going to detail a human figure, good draftsmanship is mandatory. The most unsophisticated viewer can recognize poorly drawn human anatomy.

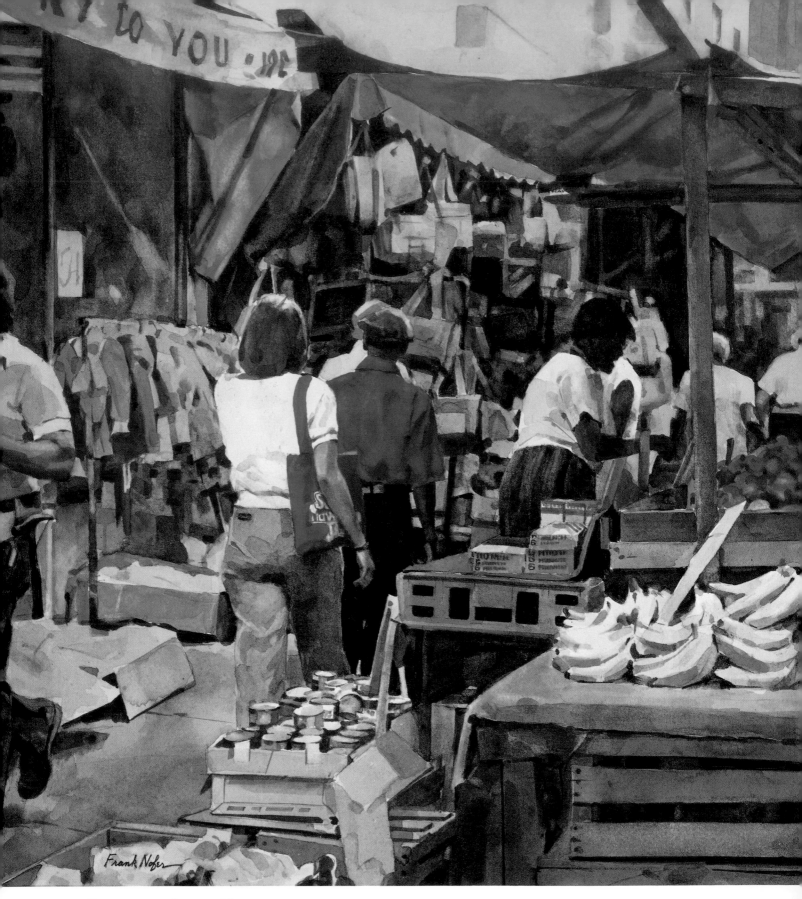

PHILADELPHIA ITALIAN MARKET, 18″ × 26″, private collection

If you are not comfortable with your drawing skills, don't attempt this kind of representational painting where complex figures dominate. A loose, impressionistic, stylized approach will excuse some borderline drawing mistakes, but any serious anatomical inaccuracies will be apparent. Incidentally, many top-notch watercolorists cannot draw figures.

Learning to draw is a time-consuming but pleasurable experience and drawing is an art form in itself. But please don't stop here . . . this is a book on watercolor.

You might enjoy the following anecdote. My dentist once told me he intended to take up watercolor. I encouraged him and suggested that learning to draw was important. He responded, "Oh, I know how to draw because of my manual dexterity." I explained that how deftly you draw your lines is not nearly as important as where you put them. I thought I established my point tactfully, but somehow my next root canal was more painful than usual.

Most representational watercolorists sketch their subject matter in pencil (a few use charcoal) before starting to paint. And some draw more comprehensively than others. I choose to make an accurate drawing of the shapes of the key elements I'm going to paint. Sometimes my drawing is rather detailed, if appropriate, and often it is not. For instance, if I'm doing a portrait, I'm careful to position the features accurately. On the other hand, if I'm indicating a group of background trees I simply sketch the configuration of the tree shapes. I'll decide later whether to delineate individual branches with my brush or merely suggest tree masses and let the viewer imagine his own branches.

There is no rule that you can't continue to refine your initial pencil drawing with brushwork.

I once studied under a highly regarded portrait painter who said, "A good painter should be able to structure a head so that the subject is recognizable prior to introducing his features." The human head is basically 80 percent an egg and 20 percent eyes, nose, mouth, ears and, usually, hair. Many artists go right for the features and, at best, achieve only a two-dimensional likeness.

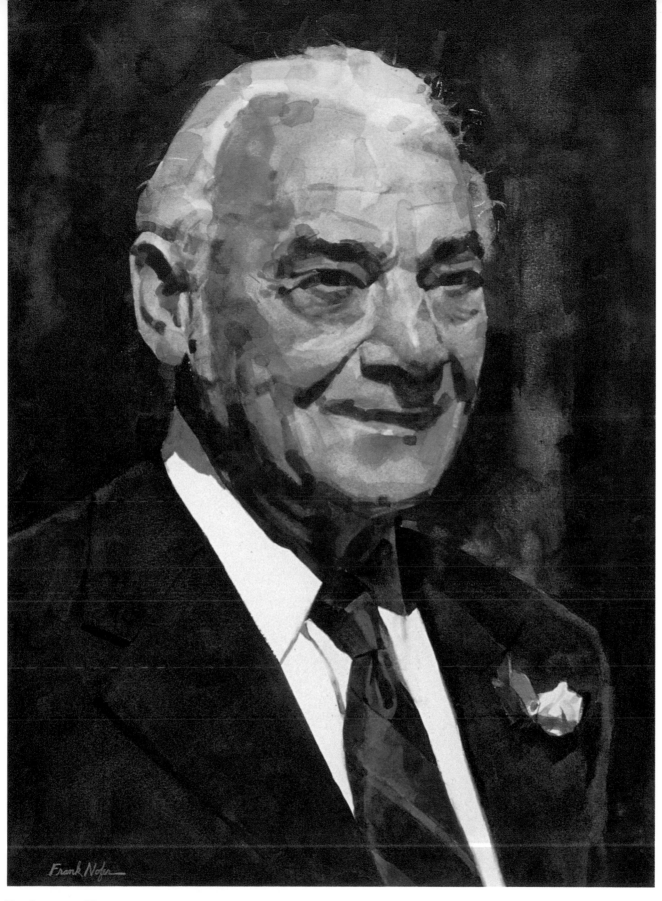

DR. LAURENT HOULE, 19¼″ × 14¼″, collection of Mrs. Jeanette Houle

Some watercolorists, including this author, erase pencil work after completion of the painting. My work seems to appear cleaner that way. Therefore, I'm not concerned with the artistic quality of my pencil lines. My drawing serves strictly as a guide for where I'm going to apply paint. Other watercolorists retain some or all of their pencil work as part of a linear component of their painting. In such cases the artistic quality of the line work is important.

We are, of course, familiar with paintings that are basically line and wash drawings. The line work (sometimes an ink medium) is the principal visual statement of the work and a few relatively flat washes add color and the illusion of mass. Incidentally, in some purist watercolor shows, exhibitors are cautioned that if pencil line work is part of the picture, the painting will be rejected.

All of the above relationships of line and paint are acknowledged art forms and the choice is yours. Personally, I prefer a watercolor painting that looks like a painting and not a tinted line drawing. We watercolorists deny ourselves the full potential and beauty of this scintillating transparent medium if we are overly dependent on line work and stingy in the application of paint.

One bit of caution. Avoid using certain greasy lead pencils that repel water.

NOONDAY SNACK, 10″ × 13⅝″, collection of Mr. and Mrs. Thomas Glassmoyer

Although the general public is more familiar with the human figure, poorly drawn wildlife seldom escapes unnoticed. In animal painting both anatomical accuracy as well as attitude of pose is necessary.

On the following page is one of the most challenging watercolors I ever attempted. I had to be at the "top of my game" to handle the demands of concept, composition, draftsmanship and technique. (My next painting was a very simple one.) . . . **Gold Cup Warmup**, 19¼″ × 22¾″, collection of the artist

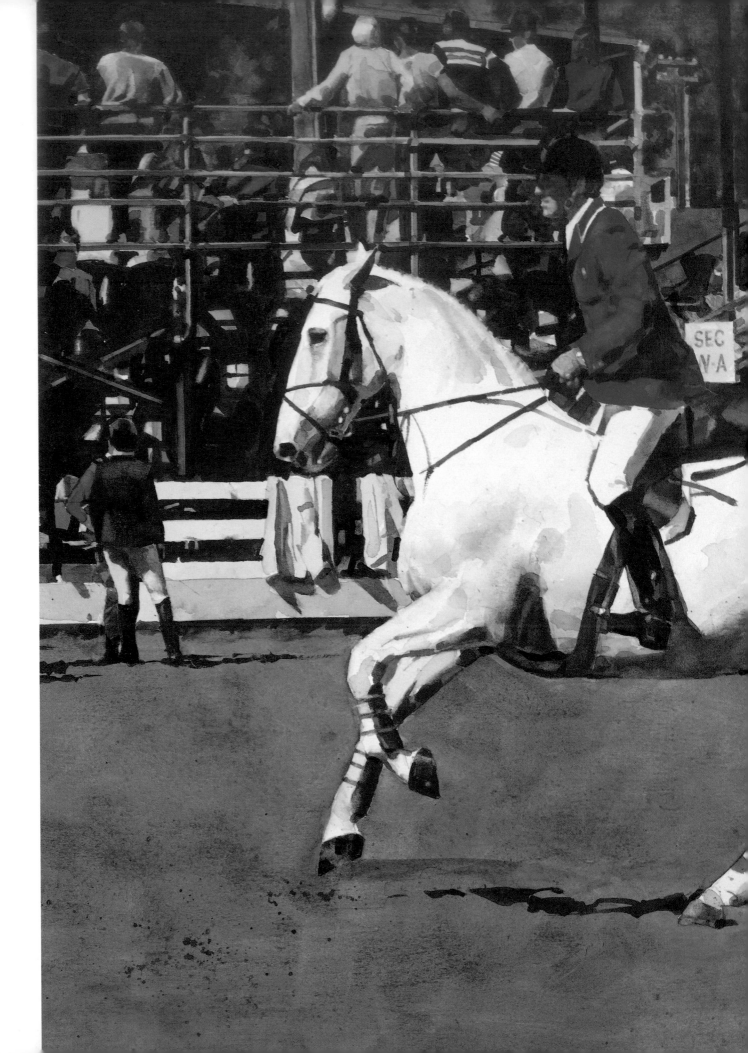

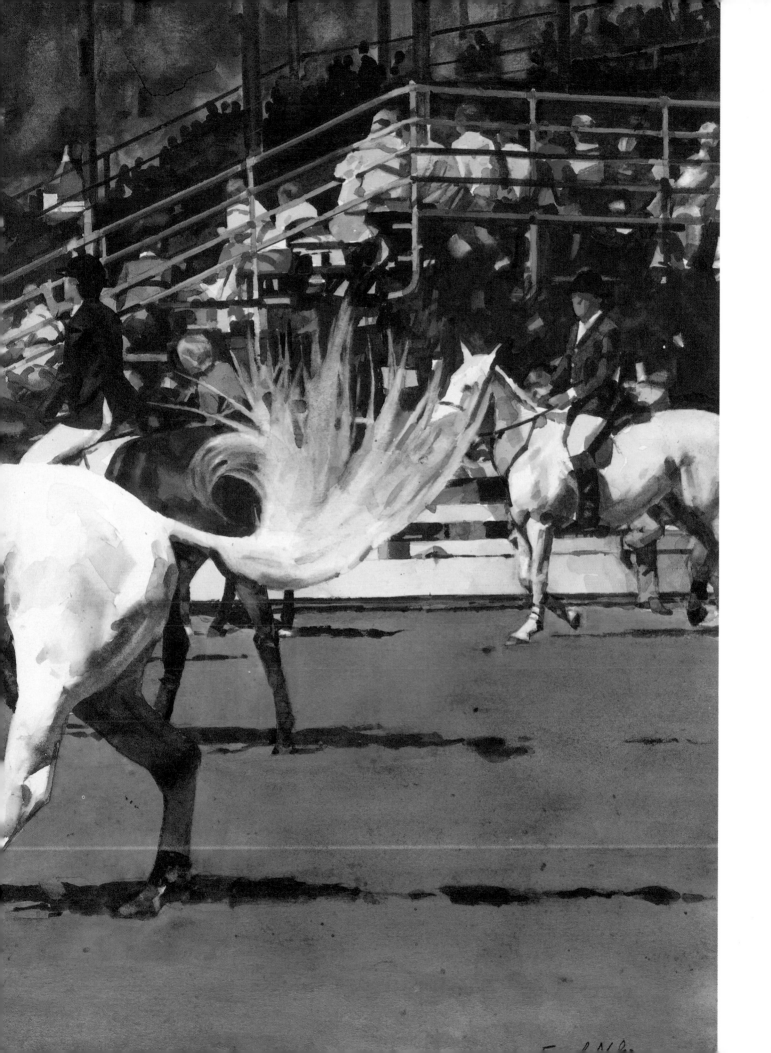

Start with an Idea

Some nonobjective artists start applying paint to their papers or canvas with nothing specific in mind. Their thought process then seems to evolve as they react to what their initial paint application suggests to them in the way of mood and design. I have seen handsome abstracts produced in this manner, as well as paintings which resemble Rorschach tests. Personally, I would be reluctant to challenge the nakedness of a white sheet of watercolor paper without a plan of attack.

If you are a representational watercolorist, every painting should start with an idea—your idea . . . a mental and visual concept of what your painting will communicate. Your idea need not be earthshaking. It can actually be quite simple. The play of light on a bouquet of flowers, the cast shadow of a tree on a white stucco wall, starlings sitting on a telephone wire, a winter landscape punctuated with patterns of snow, the excitement of people in action, a study of a weathered fishing boat captain, the rigidity of man-made city structures, etc., all qualify as ideas.

You don't have to set up your easel at the edge of the Grand Canyon to find something worthwhile to paint.

By applying what I discussed in Part One of this book about how the human eye perceives, how it assembles mini-images into a complete picture, you should come to the following conclusion: All artists do not necessarily seek the same pathway of visual stopping points as they view the same subject matter. Therefore, this allows you a personal interpretation regardless of what you paint—an opportunity to express what is special or appealing to you about your subject and to share your selective enthusiasm with the viewer.

ON BALANCE, 17″ × 25″, collection of Dr. Daniel Goldberg

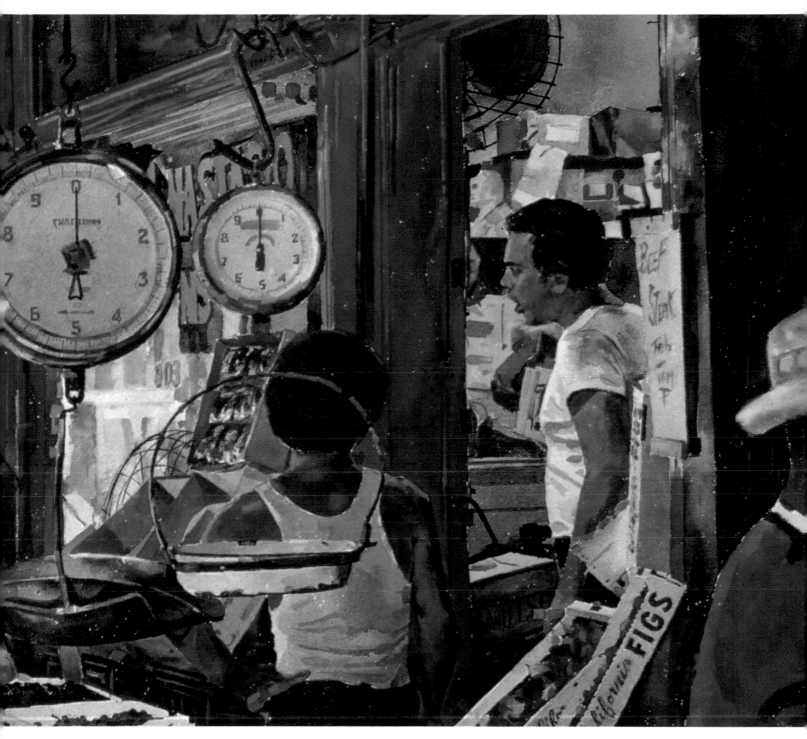

There is no single time of day when this marketplace is most exciting. It is active from early morning 'til day's end. My idea in *On Balance* was simply to capture and preserve a moment of the human activity, color and intrigue that makes this selling environment of yesteryear so intriguing.

The hunt for subject matter worthy of painting is both exciting and rewarding if you will take the trouble to seek out compositional nuances. Nature, in particular, doesn't always advertise her hidden beauties. If you walk through this world looking for obvious, perfect compositions, you might be in for a long hike.

Logic suggests that if artists were not blessed with individual viewpoints, we would be nothing more than noncreative clones.

I dare say that if you tied Andrew Wyeth to a barnyard post, from that singular position he could envision a dozen interesting concepts ranging from a distant vista to a barn swallow sitting on a nearby weathered fence rail.

So think, examine and imagine before you paint. In your enthusiasm, don't fall victim to the "ready, fire, then aim" school.

About a dozen poinsettia plants arrived at our home last Christmas. My idea was simply this—such an abundance of beauty should not go to waste. So I painted both vertical and horizontal versions which appear on these two pages. (Right) . . . **Windsor Red**, 21½" × 16½", private collection. (Below) . . . **Winter Cheer**, 16½" × 23¾", collection of J. David Donahower

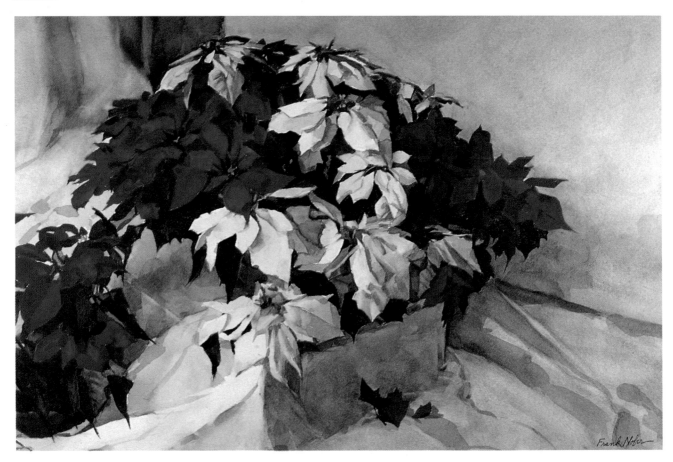

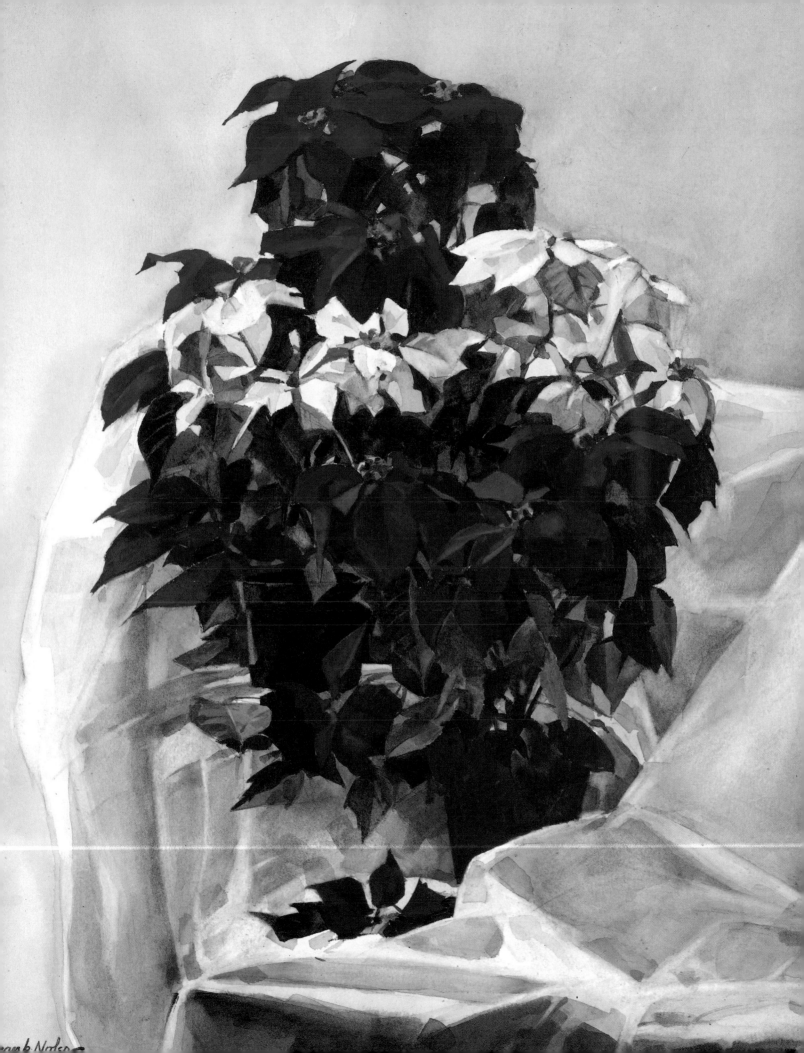

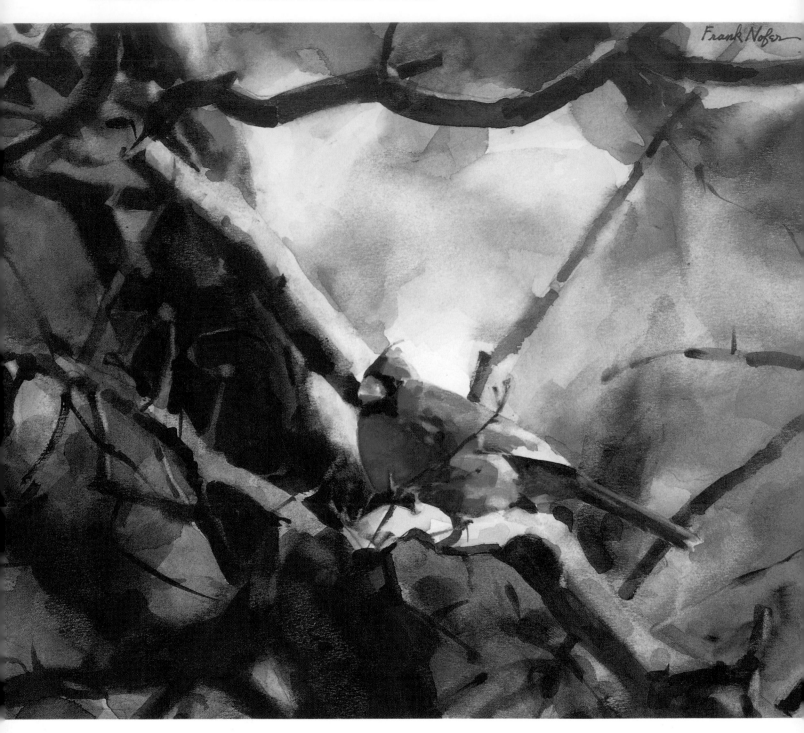

I started both these paintings with the idea of presenting the cardinals center stage and completed the watercolors accordingly. However, another idea occurred to me during the painting process: Why not assign the colorful cardinal and other small birds cameo roles in paintings that feature other subjects? Hence, the next group of paintings benefits from the introduction of our small feathered friends. *Red Alert*, of course, is a full bird study.

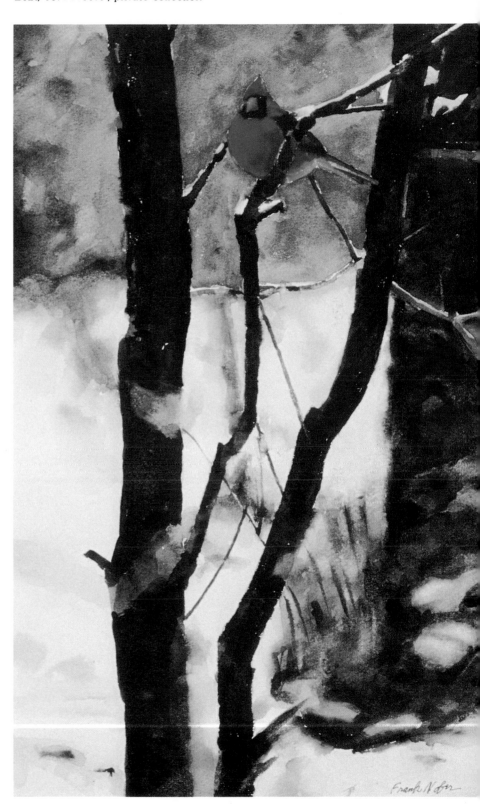

THE WOODPILE, 12″ × 14″, collection of Joseph Heenan

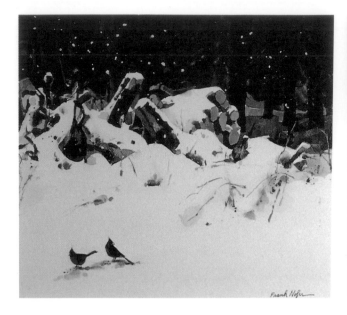

WINTER'S BREW, 13¼″ × 15¼″, collection of Mrs. Richard Unruh

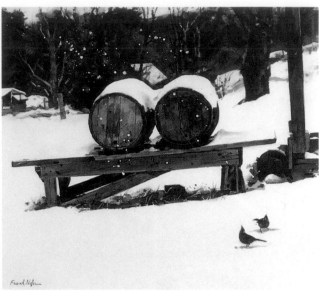

BEYOND THE THICKET, 10″ × 21″, collection of Winthrop S. Jessup

THE SEED SEEKERS, 13¾″ × 18½″, collection of Mary Ottaviano RED ALERT, 11″ × 13″, collection of Mrs. Richard Unruh

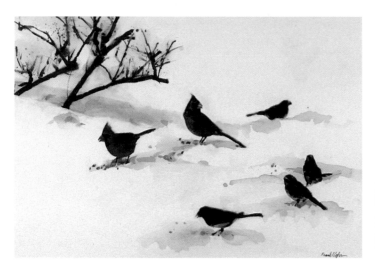 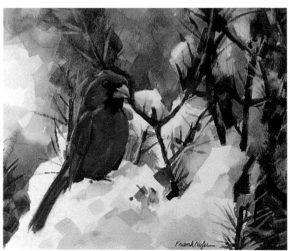

CONFERENCE BY THE FENCE, 12″ × 22″, collection of Thomas O'Neill

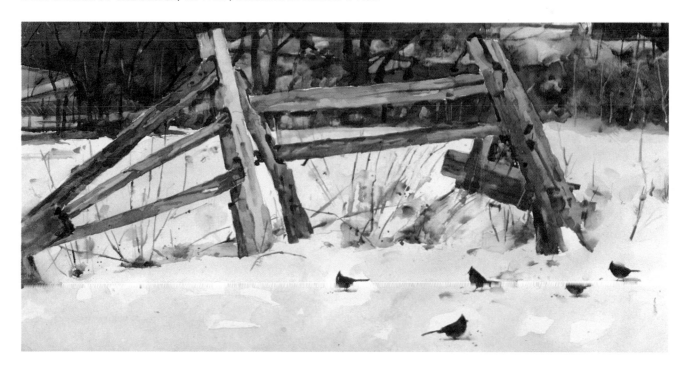

Representational Abstraction

Sounds like an oxymoron, a true contradiction in terms . . . but the fact that you are a representational watercolorist does not relieve you of the responsibility of making sound compositional statements with your paintings. In fact, you should not think of good design as being an obligation — but rather as a first priority opportunity to enhance your watercolor.

For the purpose of this discussion, let's agree that the terms *abstract design* and *composition* are pretty much synonymous. You might ask, "If I am trying to depict realistic subject matter, why should I also concentrate on its abstract content?" The answer is this: Paintings, whether they are realistic, abstract or somewhere in between, have greater appeal if they are well composed. In fact, the abstract configuration of your work — that is, the proportionate relationship of your major shapes, colors and textures — is the first thing perceived by the viewer.

There is no such thing as a first-class representational or realistic painting that does not incorporate sound abstract qualities.

I find it interesting that some individuals who wouldn't dream of hanging a purely abstract painting on their wall nevertheless give themselves away when they select a shirt, dress or rug based on the appeal of nonrepresentational patterns of shapes and colors. In effect, without acknowledging it, they are responding to abstract design.

Today's preeminent representational painters have been influenced a great deal by the abstract school of artists and have discovered that sound composition lends itself to greater believability as well as ease of interpretation by the viewer. Admittedly, as a representational painter you cannot hope to achieve the carrying power of an abstractionist who is working in bold, flat, bright-colored geometric shapes, but you can add both initial and lasting impact to your work with good design.

The multicolored triangles against two flat planes of blue — eliminate the figures and beach activity and a pure abstract emerges.

MONTEGO BAY, 14½″ × 19″, courtesy of Newman Galleries

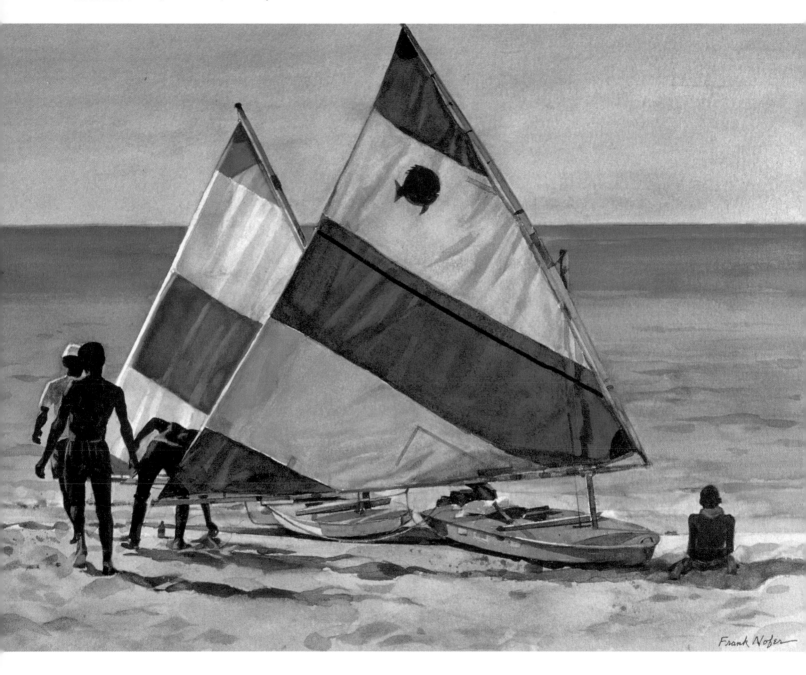

Does this mean that you have to dispense with realism and distort everything you paint to comply with abstract principles? No! You simply have to believe that good composition is important and then be more astute in your choice of subject matter. Here are three hints:

1. After determining what you want to paint, squint and break down the colors, shapes and textures into their simplest forms. Then ask yourself, "If I were not painting realistically, would the composition I am considering function as an abstract?" If not, don't proceed.

2. Carry a white card with a rectangular hole in it—perhaps 1 × 1½ inches. Place it in front of one eye and slowly scan your subject matter. This technique isolates whatever it is you intend to paint and offers instantaneous compositional options.

3. While painting on the spot or from other source material, quick thumbnail sketches are most revealing. Look at them right side up, upside down and sideways and see if they work abstractly.

In the chapter "From Photosketching to Painting" in Part Four of this book, you will get more deeply involved in rearranging, accenting and introducing additional elements as you develop your watercolors, but for now, remember this thought:

There is a dual benefit to being a representational watercolorist. You can communicate a realistic, personalized message in your work while capitalizing on the strength and appeal of good design.

Turn this painting upside down or sideways and it is still compositionally sound.

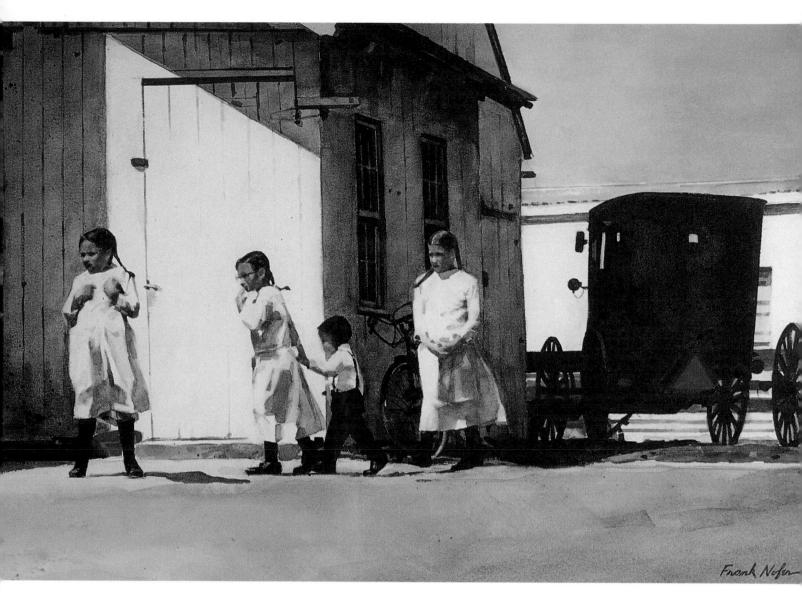

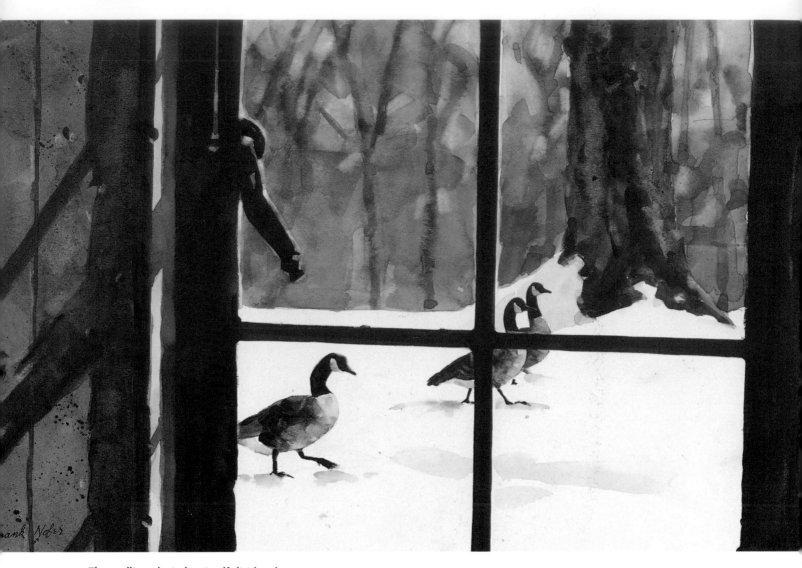

The mullioned window itself divides the painting into geometric quadrants and frames the ''passers by.''

MAINE BURST, 11″ × 16¼″, collection of Janice F. Hamilton

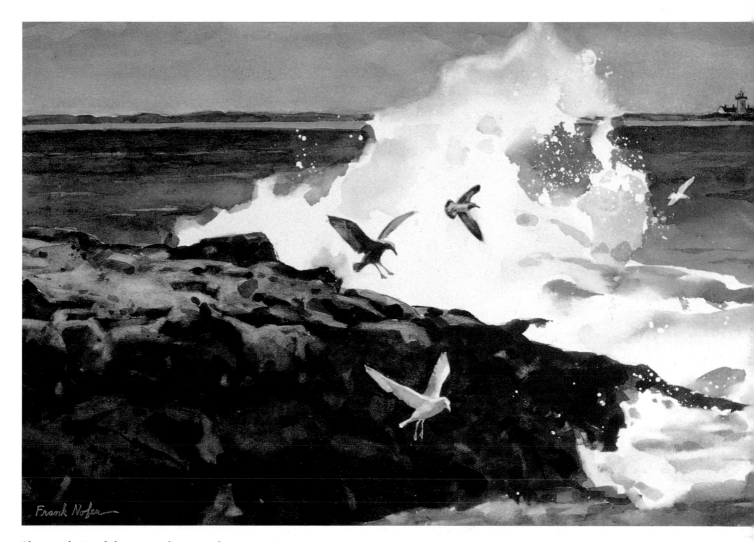

The angularity of the major shapes is the abstract statement of the painting. Also, the relationship of the silhouetted gulls against the foreground rock formation and the bursting surf is designed to be aesthetically pleasing.

HIGH DESIGN, 15½″ × 21¼″, collection of the artist

Intrinsically, the subject matter is almost pure abstraction. The painting requires a second glance to reveal it is actually realistic.

ME AND MY SHADOW, 10½" × 15¼", collection of Edward Reardon

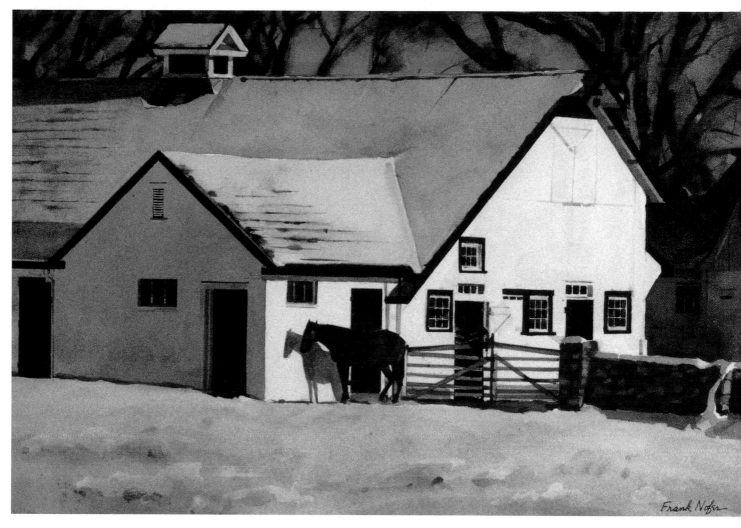

This watercolor incorporates squares,
rectangles, triangles, trapezoids — almost
all of the shapes in the graphic design
repertoire — except the circle.

Composition —
The Balancing Act

Our early art training taught us that a painting should have a center of interest. This axiom is at best a stifling truism. It connotes symmetrical design and suggests that a single area of importance should appear like a bull's-eye in the middle of your painting. While this dart board concept is both a legitimate and safe approach to painting, it severely limits other compositional options.

The artist should definitely control the viewer's visual pathway through a painting and in doing so must engage in a balancing act if the composition is asymmetrical in nature.

Asymmetrical or unorthodox design offers tremendous variety to a painter's compositional repertoire if he can maintain a sense of visual balance.

The realistic painter, Winslow Homer, thoroughly understood the challenge of unusual composition and left a legacy of *representational abstraction*. An excellent example is his famous watercolor, *Palm Tree, Nassau*, in which he offsets a large palm tree in the right foreground with a tiny red flag and white lighthouse in the distance—and thereby stabilizes the painting.

Surrealist Joan Miro possessed an incredibly intuitive design sense. At times he apparently placed vibrant globs of color on his canvas and then fine-tuned their relationship with sensitive linear scribbles.

The ability to capitalize on the daring intrigue of asymmetrical or unorthodox design is perhaps best understood if we study Alexander Calder's three-dimensional mobiles and stabiles. His intermix of large and small objects, connected by delicate rods and brought into balance by precisely calculated support systems, is translatable into two-dimensional graphics. Simply put, the *distance* between large objects in the foreground and small ones in the background weighs heavily in the balance.

If you don't think the small black window lends a sense of resolved balance to the array of foreground tulips, place a small white paper over the window and the painting appears bottom heavy.

A subtle, anticipated balance exists in this painting. At first glance there appears to be a visual void on the left, but your mind predicts the squirrel will move in that direction and thereby fill the empty space.

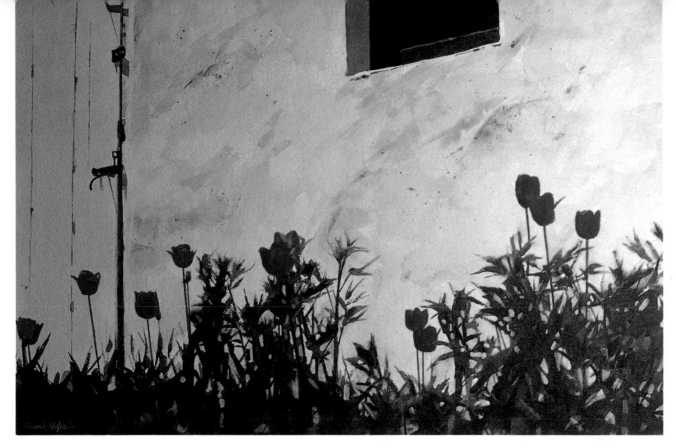

ARMSBY'S TULIPS, 18″×25″, courtesy of Ris Galleries

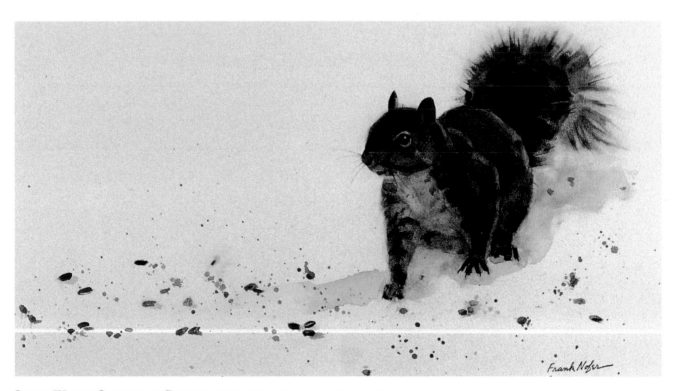

GUESS WHO'S COMING TO DINNER, 7⅝″×14″, collection of Mr. and Mrs. George Hancock

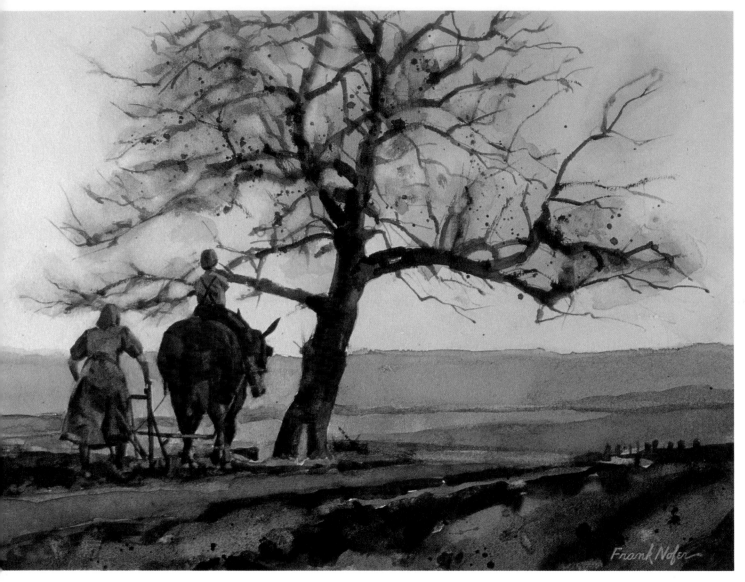

The tree branch that extends to the right
serves to counterbalance the figures on
the left.

DAPPLE, 10″×14″, collection of Mr. and Mrs. Joseph Parsons

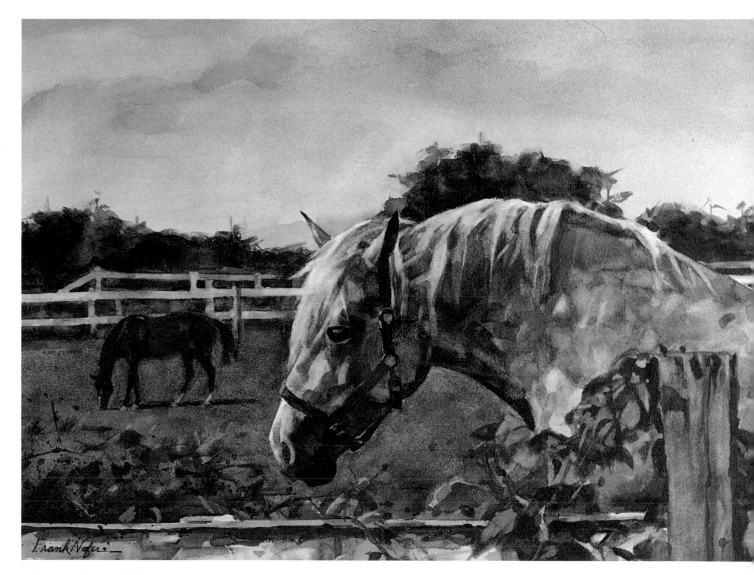

At the conclusion of this chapter I mentioned that *distance* weighs heavily in balancing the composition. D*apple* is a good example of this principle and for the purpose of clarity, let's apply this equation: SH+D=LH (Small Horse plus Distance equals Large Horse).

The Importance of
Negative Shapes

The term *negative* has various connotations. If a corporation has negative earnings, that's bad. If a doctor tests you for a major ailment and the results are negative, that's good. Neither meaning of the word applies here.

In a representational painting, those areas in which you include no specific content or which you actually leave blank or very lightly tinted are negative shapes. For instance, if you painted the three basic graphic symbols—a square, triangle and circle—against a white background, the symbols would be positive shapes and the leftover white areas would be negative. Every time you apply paint to paper, you produce two shapes: the positive shape of the object you paint and the remaining area that surrounds it. Defined patches of snow in a winter landscape, bunkers surrounding a golf green, white clouds against a blue sky, and, very typically, the light background against which you may silhouette trees, mountains, buildings or even figure studies are all negative shapes.

Granted, there are some situations where detail throughout the painting leaves little room for obvious negative areas. However, in most paintings the artist tends to concentrate on dominant positive shapes and lets the negative ones fend for themselves. This is dangerous. Negative shapes are important and should not be left to accident. How important are they? Dwell on these two thoughts for a moment. Is a chessboard a white board with black squares or a black board with white squares? Is a zebra a white animal with black stripes or vice versa? In both these cases, the negative and positive shapes challenge each other and incite visual war.

Here are four hints for handling negative spaces:

1. Negative shapes are usually more effective and less intrusive if you keep their configuration simple.

2. There's nothing wrong with allowing a negative area to comprise most of your painting. A small red barn well placed against a blanket of snow, or two distant figures on a broad expanse of beach, suggest dramatic and effective use of negative space. However, avoid an equal distribution of positive and negative shapes—you may wind up with a chessboard effect.

3. Sometimes it is appropriate to soften the edges of negative shapes so they don't upstage the positive ones.

4. Consider those areas where you *don't* apply paint as important as those where you do.

SAILS, 6¾″ × 10″, black-and-white pen-and-brush drawing by Jean Baber

My friend and fellow artist, Jean Baber,
was kind enough to lend me her simple
rendition of *Sails*. I can't think of a more
direct and provocative play of positive
and negative shapes.

DOUBLE ZEBRA, 22″ × 30″, by Caroline M. Thorington

This dramatic, yet sensitive lithograph by the accomplished artist Caroline M. Thorington asks the question, "Is a zebra a white animal with black stripes or vice versa?"

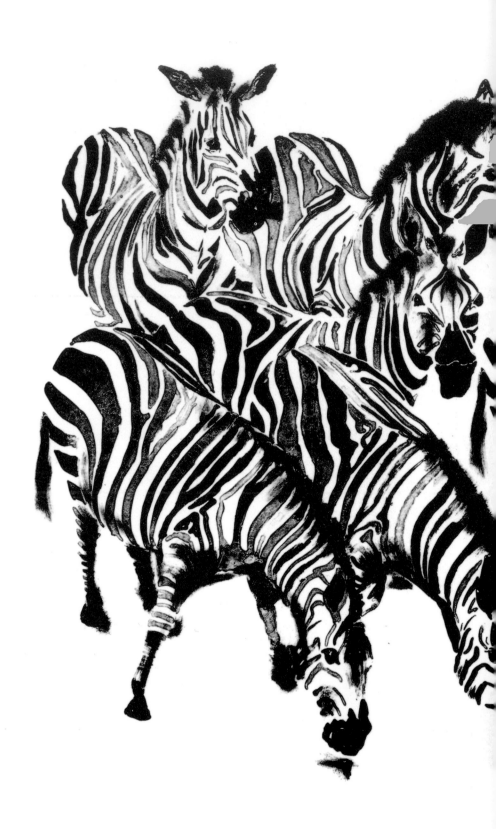

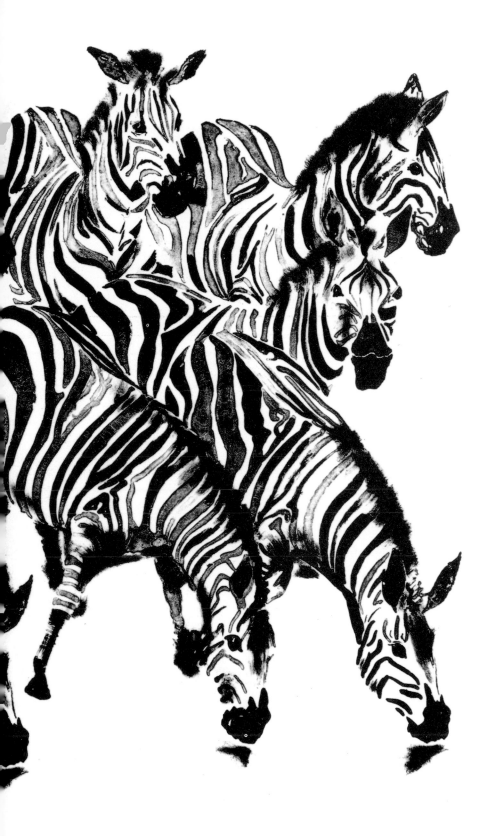

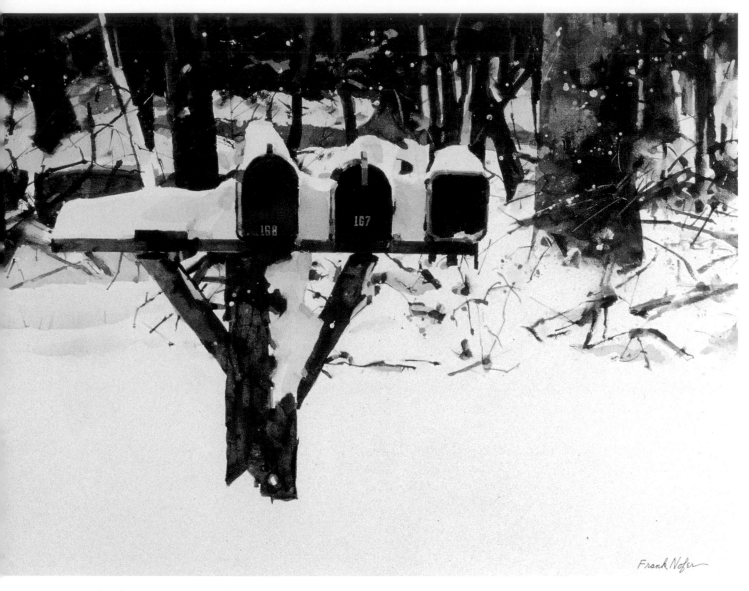

The white areas (negative shapes) comprise about 60 percent of the picture. However, they play the important role of setting off the shapes and textures of the mailboxes and background forest.

BUGGY STOP, 12¼″ × 17¼″, courtesy of Newman Galleries

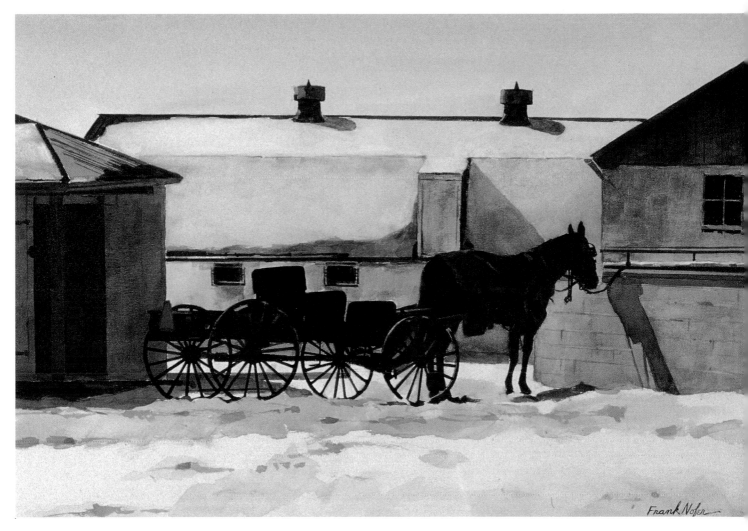

Buggy Stop doesn't have the visual impact of a pure geometric abstract, but if you examine the shapes, colors, texture and content, you will find attention to design is evident.

Color Chords — Not Colors

When painting, I think of *color* as a collective noun meaning *chords of colors* rather than an individual hue. There is no such thing as an ugly color by itself, but there are unpleasant or clashing relationships of colors.

A classical music orchestration provides a perfect analogy. There is no such thing as a bad note, but there are certainly unpleasant combinations of notes. The overall richness and depth of an orchestral piece is produced by chords (combinations of harmonious notes), just as the richness and depth of a painting is achieved by chords (combinations of harmonious colors). The analogy can be carried one step further. Major and minor musical chords produce varying moods. The same is true in painting. Properly related dark blues, greens, purples, etc., will produce a subdued mood while bright colors such as reds, yellows and oranges will strike a happy chord.

I just examined a Winsor & Newton watercolor chart that features eighty-six colors available to the artist. Each color is attractive — but there is a reason. The eighty-six swatches of color do not touch each other. They are separated by white so that each can be considered on its own terms. There is a very important lesson to be learned here.

Individual colors, particularly bright ones that basically clash, can live as good neighbors if they are separated by white or black.

The geometric painter, Mondrian, might come to mind. By 1919 he used only straight lines of black and white to separate his primary colors. And his rectilinear approach to using black-and-white stripes to prevent his vibrant reds, yellows and blues from abutting has greatly affected contemporary architecture, interior design, and today's art.

Many of Dong Kingman's watercolors sparkle with bright primary colors, but he is careful to play them against white backgrounds.

I don't like hard and fast rules for color usage. There are books filled with diagrams and formulas depicting color relationships which I find more complicated than the instructions for hooking up my VCR. If the watercolorist will combine a basic hint from nature regarding the intermix of colors together with what his eye tells him, he won't need charts and a computer each time he dips his brush in paint. Here's what I mean:

Let's examine nature's spectrum — the series of colored bands diffracted and arranged by the passage of white light through a prism. The colors in order are: red, orange, yellow, green, blue, purple (violet) or vice versa depending on whether you start with the shortest or longest wavelength. This natural phenomenon tells us that cool colors relate well and warm ones do likewise. By muting these colors, and introducing browns, tans and grays, you can create subtle and expanded chords. And, as in music, you can add a touch of tasteful dissonance for special effect, but don't abuse the privilege.

What I've said above will be for naught if you misinterpret one of the fundamental color dictates we learned in grammar school art class. While we were told that there are six basic spectrum colors: red, orange, yellow, green, blue and purple (violet), and nobody argues with this, we were also informed that green is the *complement* of red, blue is the *complement* of orange, and yellow is the *complement* of purple. Let's clear up this latter statement. To *complement* usually means *to enhance*, but by dictionary definition *complementary colors* oppose each other . . . and, in actuality, they do. In their pure form they vibrate annoyingly when they appear side by side. Try playing checkers on a board made up of red and green squares of the same bright intensity, but have the aspirin bottle handy.

You seldom see a sour color chord in nature and yet, in a flower garden for instance, she positions purples against yellows and reds next to greens and the colors do not clash. I've

often pondered why—and I think this is the answer. At any given time, nature bathes (or glazes) her subject matter in a uniform light. On a bright sunny day everything is influenced by a common denominator of warm light. On a gloomy day, the lighting scheme is blue-gray.

If you picture a group of people in multicolored clothes sitting in front of a blazing hearth, all colors appear in sympathy because of the overriding warm glow of the fire. This is an exaggerated example of nature's lighting principle.

For hundreds of years, painters, particularly those who work in oils, have used this *glazing* technique to pull together areas of color that are out of balance. And so it is nature's overall *glazing* technique that enables her to make harmonious color chords out of seemingly opposing colors.

The same bright red is a different red when viewed outdoors on a sunny day than it is on a cloudy day. If evaluated under incandescent light, it is much warmer than it appears under cool fluorescent illumination.

As a representational watercolorist, if you want your color chords to ring true, don't automatically reach for cadmium red every time you see a bright red barn door. Keep your colors in context with the overall lighting conditions. That bright red door may be closer to vermilion on a sunny day or it may approach alizarin crimson if the sky is overcast.

There are two other thoughts I would like to pass along:

1. Individual colors are frequently more distinguishable as separate hues under diffused light.

2. The illusion of brilliance produced by strong, direct sunlight is frequently attributable to high black-and-white tonal contrast rather than intensity of color.

So, regardless of what you paint, examine and analyze your color chords and don't rely on easy presumptions that in all cases "roses are red, violets are blue" Some years back there was a TV commercial that extolled the health benefits of margarine, which I've paraphrased here: It's not nice to fool with Mother Nature. That advice is as appropriate to your painting as it is to your cholesterol count.

For demonstrative purposes, this is an imitation of a typical Mondrian painting. One might presume that the three primary colors—red, yellow and blue—would clash. However, the black bars that separate them allow each color to be appreciated as an individual hue.

Free-floating bright colors and shapes against a white field is always a safe way of producing visual excitement, as long as the colors don't abut. Each color is a singular statement and no chords are involved. Some watercolorists will clear a pathway of white in their paintings so they can decorate or excite that area with almost an arbitrary application of non-abutting bright colors.

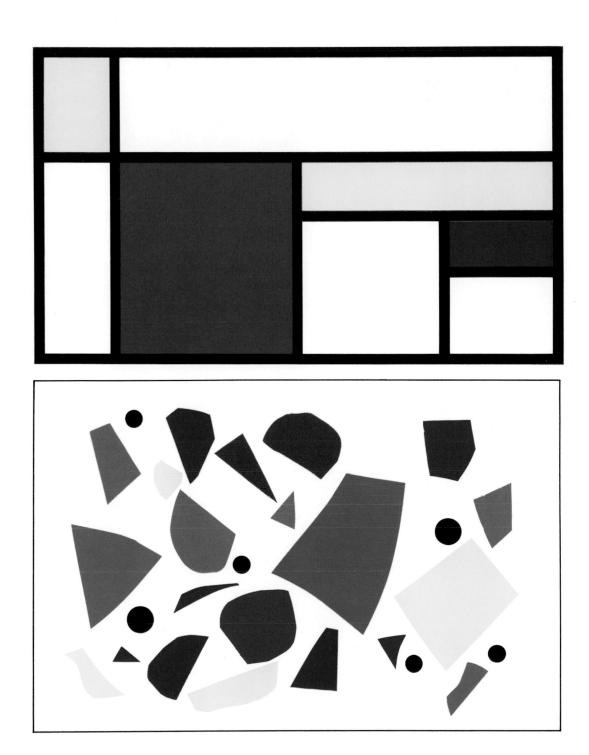

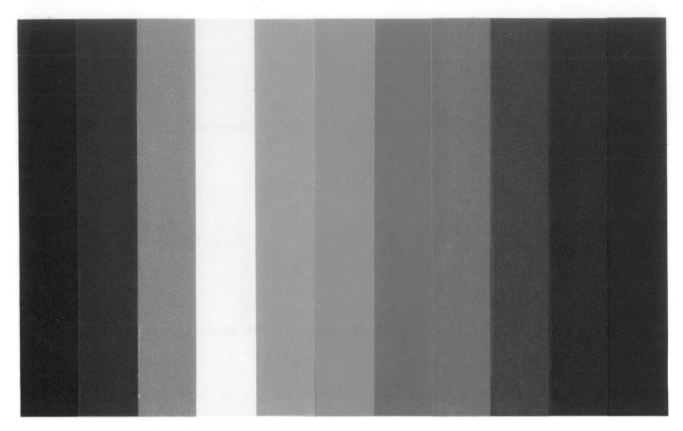

Any four of the abutting colors taken in
sequence from this spectrum will produce
a rich, compatible chord. Mix up the
sequence and dissonance occurs.

I enjoyed writing every word in this book
and producing every watercolor and
demonstration, except this one. How
much color vibration can the human eye
withstand?

Reds, pinks, magentas, purples and greens keep close company throughout this watercolor. Why don't these colors clash? The answer is—they are all conditioned or muted versions of pure color forms. Those who paint straight from the tube, beware.

RHODIES AND PEWTER, 21¾" × 30", collection of Mr. and Mrs. Thomas Sander

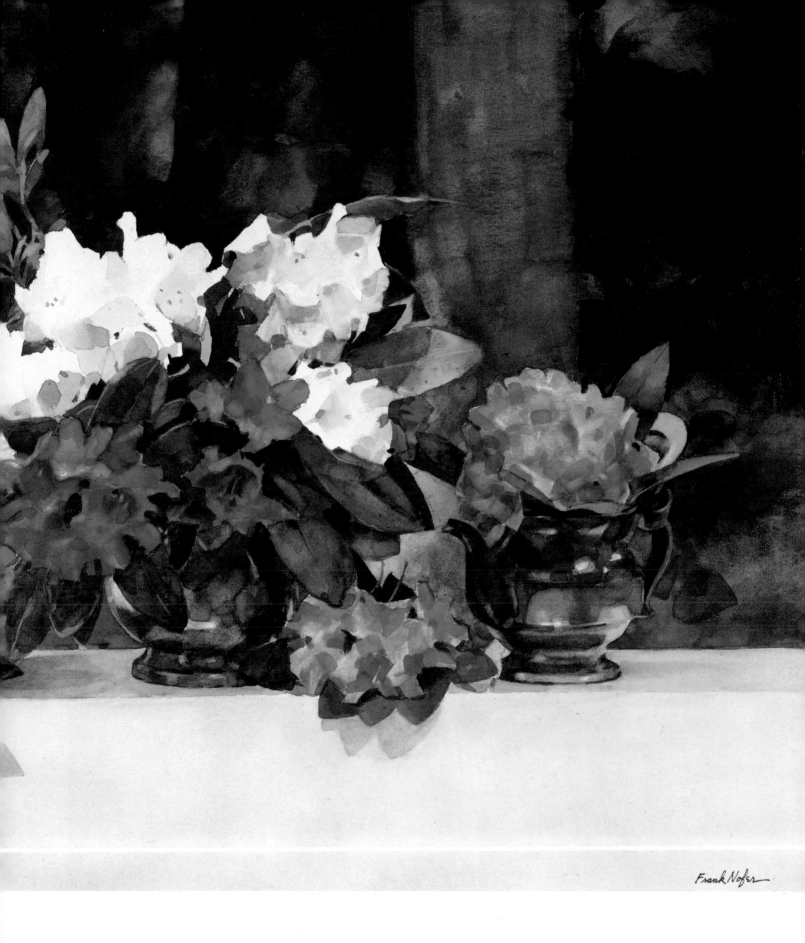

Frank Nofer

75

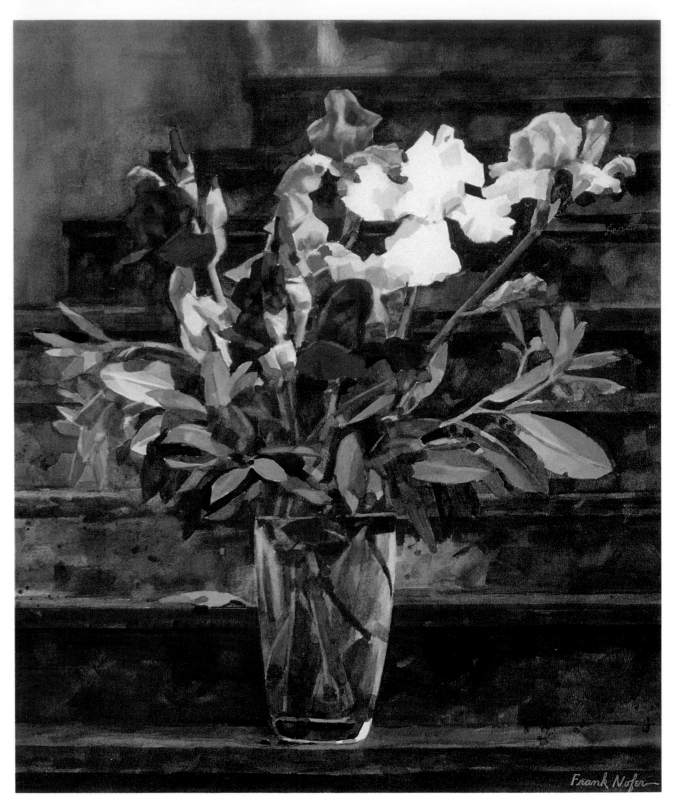

Left: I am frequently asked how I achieve rich darks. I discuss this comprehensively in "Forgiveness Techniques" on pages 88-96. However, this watercolor is an example of the principle involved. The background is not a single, flat, heavy color. Rather, it is composed of dark, muted colors, some of which are harmonious and some of which are slightly dissonant. The overall effect keeps the background from becoming static.

A casual glance at the painting below suggests it could be a study in sepia. Closer inspection reveals that it is made up of dozens of variations of browns and green-browns. The entire watercolor stays within a single expanded color chord.

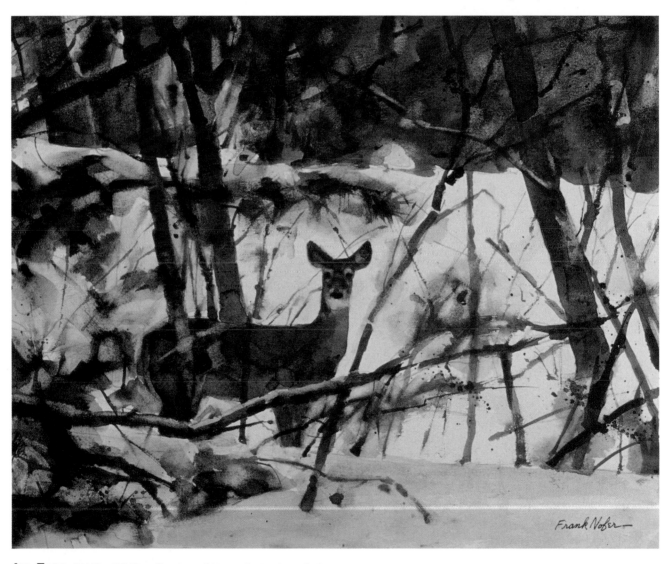

ALL EARS, 10¼" × 12¾", collection of Mr. and Mrs. Joseph Parsons

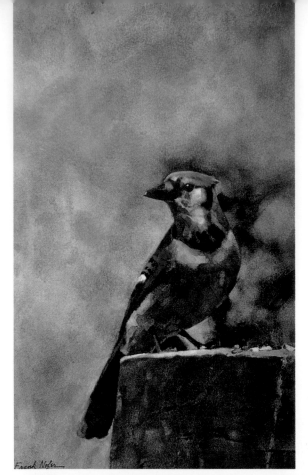

MR. BLUE, 14⅞″ × 8⅞″, collection of Ann Elder

Mr. Blue and *Heads Up* both play chords of blue against background chords of green. Since blue and green are reasonably compatible in their raw stage, they get along even better when their intensity is reduced.

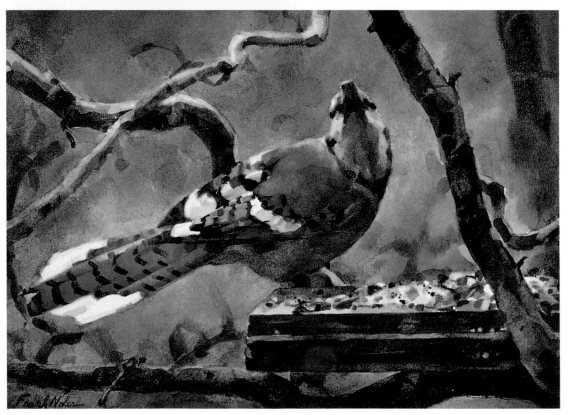

HEADS UP, 8¼″ × 11″, collection of William Morehouse

PART THREE

FORGIVENESS
Watercolor's Best Kept Secret

The "Love-Hate" Relationship

Once the reader understands and acknowledges: (1) how the eye perceives, (2) the importance of personal conceptualizing, and (3) the significance of good design, you should experience a surge of confidence. Here's why. As a representational watercolorist you are now aware of these three major components of a successful painting.

You are halfway there. Most watercolors are headed for mediocrity if any one of these components or concepts is ignored. Now, I wish I could say, "Just add water and pigment and the recipe for a sound painting is complete." Such is not the case.

There are books which explain how to paint sensitive flower studies, believable portraits, vibrant landscapes, etc., and much of the advice offered is helpful. But for real gratification, there is only one way to paint and that is *your* way.

Throughout this book there are many reproductions of my work accompanied by specific explanatory captions. I hope you will study these paintings and regard them as useful teaching tools in the development of your own style. They demonstrate a broad spectrum of paint application from wet washes to subtle texturing and you will find there are few painting problems that I have not addressed. You are welcome to pass judgment on whether I practice what I preach.

Since the reader is probably beyond the *primer* stage, I am not going to burden you with a discussion of the fundamental properties of the medium. Rather, let's address what I regard as the major stumbling block when it comes to actually applying paint to paper. There exists an abiding fear that the medium offers no forgiveness.

Most representational watercolorists have a "love-hate" relationship with the elusive transparent watercolor medium.

We are in love with the inherent, spontaneous beauty that transparent watercolor gratuitously offers. But we hate it when we louse up with muddy washes and a host of other mistakes. Read on!

I knew beforehand that *Rockin' in the* USA would require subtle manipulation of tone and color throughout 80 percent of the painting. The only easy part would be painting the flag—I accepted the challenge.

Overcoming Intimidation

"Painting with transparent watercolor is extremely difficult . . . one mistake and you're done." For a period of time in my painting career, I found myself giving lip service to this old wives' tale. Then I made up my mind that life is too short to be intimidated by the medium I love.

After some experimentation, I found, contrary to popular belief, that watercolor offers forgiveness for many painting errors, and will frequently forgive more than once. With the right techniques, the medium can extend to the painter the same options enjoyed by the writer—the opportunity to edit, enrich, emphasize and refine, and to do so without a muddy conclusion. Therefore, the following three chapters offer tips to fellow painters on "forgiving" materials and ten solutions to common painting problems in watercolor.

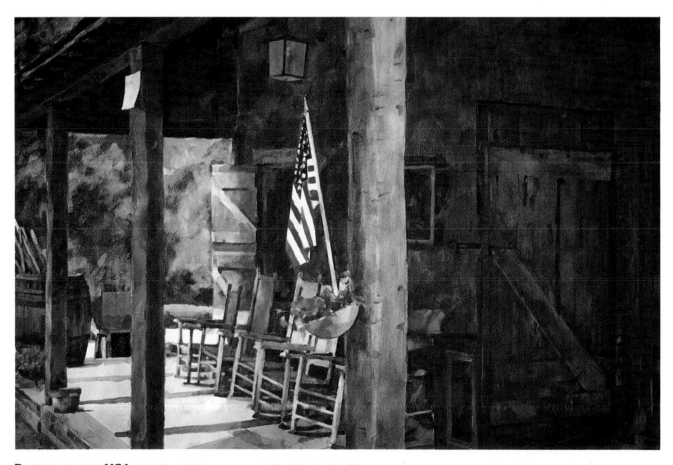

ROCKIN' IN THE USA, 18¾" × 27¾", courtesy of Chadds Ford Gallery

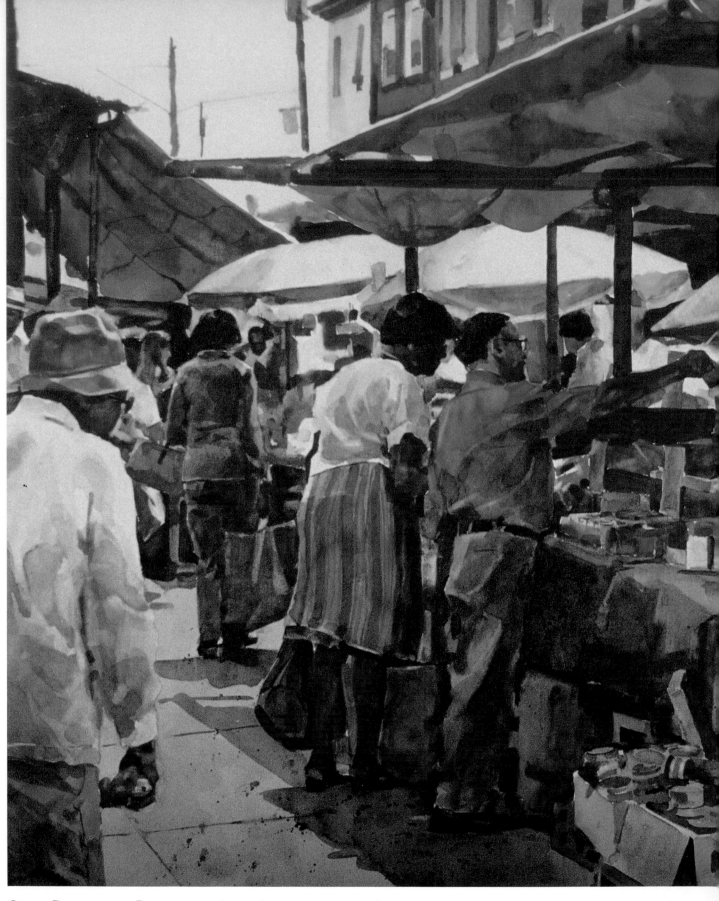

SOUTH PHILADELPHIA BARGAINS, 20½″ × 26⅛″, private corporate collection

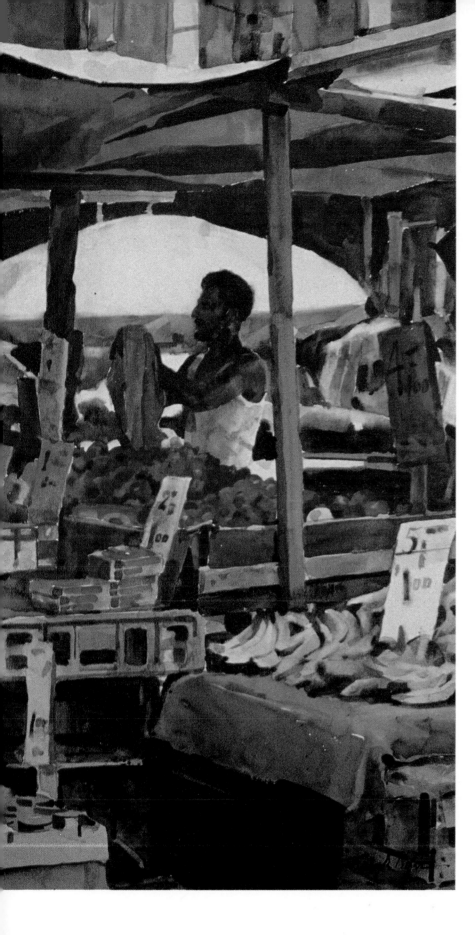

Painting a single figure study is enough to make many watercolorists pause. Painting multiple figures in conjunction with vegetable and fruit still lifes might tempt some painters to run for cover. I'll admit I paused before starting but then I picked up my brush and painted full speed ahead.

The Right Paper

Paper is the most important single ingredient in the forgiveness recipe. For me, watercolor paper must meet the following five criteria:

1. The paper must be 100-percent rag for purposes of toughness and permanence.

2. Each sheet must be bright, with no evidence of yellowing.

3. Good "color holdout" is mandatory. This means the paper should allow your color, however subtle, to sit up on the surface without losing intensity as the washes dry.

4. The texture must be compatible with brushstroke production. I personally prefer medium and rough surfaces. Whatever the texture, it should not have an obvious mechanical pattern.

5. The paper must extend to the artist maximum possibilities for correction or editing, and not dictate limited alternatives because of its own rigid properties.

In short, the performance of watercolor paper must immediately reaffirm the artist's expectation that initial application of paint is not sacrosanct.

Within reasonable parameters, the paper should permit colors to be lightened, darkened, intensified, muted, scrubbed, washed over again and again and even removed. And after any of these torture tests the surface must return to a paint-receptive condition.

The top-of-the-line papers produced by most manufacturers easily satisfy the first four requirements; only a handful meet criterion number five. After experimentation with a variety of papers, I have found two that work best for me: Strathmore Gemini, all-rag, 300-pound rough; and Strathmore 112, all-rag rough, which is pre-mounted on a Crescent board backing. Both papers qualify in all categories and excel in their forgiveness properties.

The Strathmore 112 rough is really more like a medium-surface paper because the sheet is compacted somewhat in the

mounting process. But dry-brush effects are created more easily on the 300-pound Gemini paper which offers the advantage of a truly rough surface. If the subject matter requires detail and I am willing to generate my own texture, then I choose the Strathmore 112. If the picture is bold in structure and easily achieved dry-brush effects are welcome, I opt for the Strathmore Gemini 300-pound rough. Incidentally, this 300-pound Gemini is sufficiently heavy that it seldom requires stretching; nor, for that matter, does the board-mounted Strathmore 112.

In passing, I probably should call attention to the hot press, smooth-finished papers that are available. They are in a different classification than most watercolor papers and I would describe them as *slippery under foot*. You can slide your washes around with ease, but when you want your pigment to grab, it's likely to skid. It takes a special skill to handle the smooth surface unless you are working exclusively with small brush strokes to achieve fine detail.

Note: As of this writing, I am aware of four new entries on the watercolor paper scene. The well-known Arches watercolor papers are now available in board form. Saunders is promoting its Waterford series of papers distributed by Hunt Manufacturing Co., and I've heard good reports from several users. Winsor & Newton has just introduced its own selection of papers. Also, Crescent is advertising "Premium 100% Acid-Free Watercolor Board" in three surfaces: 5117-Rough, 5112-Cold Press, and 5115-Hot Press. I am reasonably certain that the new 5112 is the same paper surface I have referred to in this chapter as Strathmore Rough 112 mounted on a Crescent board. Since I have not had the opportunity to experiment with these papers, I cannot offer my personal endorsement. However, the reputations of these manufacturers suggest their papers are probably of the highest quality.

Do your own experimenting as to what paper or papers serve your painting style best. But, don't try to save a buck. Inferior brushes, pigments and papers are not conducive to superior watercolors.

Basic Painting Equipment

I use the standard range of fine, round red-sable brushes together with large, flat wash brushes for applying watercolor, and I always choose the largest brush possible for working in a given area. The much less expensive, round acrylic brushes are satisfactory, but they have a limited life-span—they lose their points. HB pencils, Maskoid (a liquid block-out agent), a rubber cement pickup to remove the Maskoid, a hair dryer, and an abundance of clean water complete my painting accouterments. You will not find a salt-cellar on my taboret. My reaction to excessive use of salt on watercolors or food is identical—elevated blood pressure.

My palette of colors is more simplified than most. I use Winsor & Newton professional tube colors that are squeezed out fresh for each painting session along the edge of a large, white, heavy ledger-bond tablet (32-pound, medium-surface paper). I do not use pan colors or painting trays; all washes are mixed on the bond tablet itself and successive clean pages are ready and waiting.

Basically, ten permanent colors comprise my palette: alizarin crimson, cadmium red, cadmium yellow pale, yellow ochre, burnt sienna, warm sepia, Hooker's green dark, Winsor green, Winsor blue and Payne's gray. I find black unnecessary. Almost any hue can be produced from this palette and it keeps things simple. Also, a limited palette disciplines painters. It obligates them to manufacture or mix their own colors and thereby understand color intermixes better. I presume and hope the reader is not a *straight from the tube painter*. Admittedly, I will add a special color if the subject matter suggests it. Chinese white is not part of my palette since I don't use opaques.

Caution: Become familiar with which colors in your own palette are staining and therefore difficult to adjust or remove. Pigments that are *not* intense in their hue and all the earthen colors—siennas, sepias, ochres and umbers—are more workable than the bright reds, blues, greens and magentas. Try painting a full-strength, 2-inch square patch of each color in your palette on a scrap of your favorite paper. When dry, scrub the individual colors vigorously with a wet sponge to determine to what extent each can be lightened, and to what degree the hard edges of your squares will soften. Observe, let dry and then note how easy or difficult the remaining color is to erase. Keep your experiment for future reference.

In conjunction with the orthodox painting equipment I have just described, the photo at right depicts my "tools of forgiveness." Now, let's see how they are used in action.

Here is the array of my "forgiveness" tools—those items used to push, lift and otherwise manipulate watercolor after it has been applied to paper. From left to right you will find synthetic, chisel-edged bristle brushes; sponges; a range of pencil and ink erasers; drafting tape; X-Acto knife and single-edge razor blade for scratching in small whites; fine sandpaper and emery paper for smoothing abused paper surfaces; and a roll of paper towels.

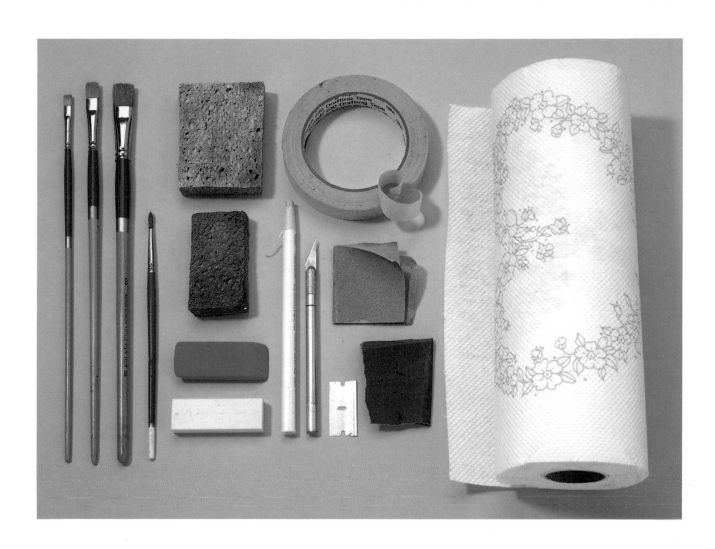

Forgiveness Techniques

Here are ten solutions to some common watercolor problems:

Problem #1: You have just laid an ill-suited wash— one that is too dark or obviously wrong in color.

Solution: Grab an absorbent paper towel and immediately blot up the wash before the capillary action of the paper allows the paint to settle in. Permit the paper to dry and apply a proper wash. A roll of paper towels, like a fire extinguisher, should always be near at hand. Also, a paper towel is a valuable painting tool when used to pick soft, light areas out of a semi-dry wash, such as in the depiction of cloud formations.

Problem #2: With loving care, you have over-detailed an area of your painting, and this section has assumed a higher visual priority than intended. It needs to be subdued.

Solution: Take a flat bristle brush of appropriate size, dampen it as needed, and gently massage or stroke that area of the painting. The darks will lighten, the lights will darken, the hard edges will break and the entire section will fuse into a more simplified visual statement. Sometimes less becomes more.

Problem #3: You want to excise a section of your picture—remove paint right down to the paper.

Solution: Bearing in mind that staining colors are more difficult to remove, start by scrubbing the area with a synthetic sponge, allow to dry and rescrub, if necessary. Assuming the paper still retains some of the pigment, allow plenty of drying time, and then go to work with a large ink eraser followed by a soft pencil eraser until the white paper reappears. Caution: If the paper is still wet when you erase, it will "oatmeal" (that is, will come up in small balls) and you must then turn to a higher source for forgiveness.

Since more than one forgiveness technique may be necessary in any given painting, I will point out those solutions I used in the following series of watercolors.

Steppin' Out—Solutions 1 and 2. My initial wash on the breasts of the geese was too dark and would have prevented the geese from "steppin' out" from the background. Immediate sopping up of the wash with a paper towel allowed me a fresh start. Also, over-detailing of the trees responded to bristle brush massage.

STEPPIN' OUT, 11¾" × 15¼", purchased through the Philadelphia Art Museum

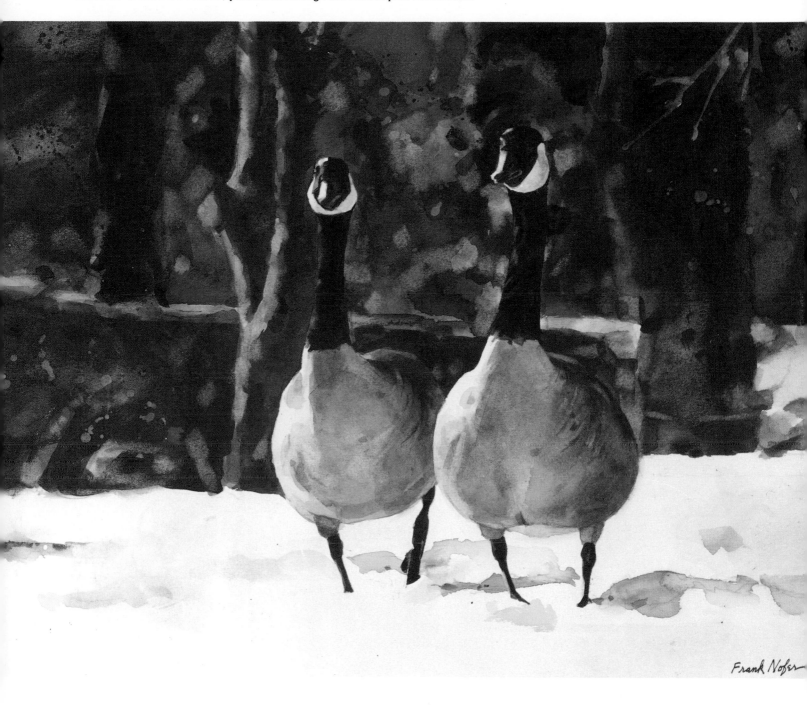

Frank Nofer

Problem #4: Somehow, an area of your watercolor has become too dark, muddy or opaque. It needs to be lightened or lifted.

Solution: Thoroughly wet a flat bristle brush and scrub that section until the paper starts to release the pigment. Blot with an absorbent towel. Repeat the process if necessary. Summon a certain amount of courage when you attempt this technique. Tentative scrubbing can, on occasion, make things worse. Remember, if you remove too much paint, it is a simple matter to reapply washes after the surface has dried.

Problem #5: Scrubbing or other abuse of the paper has caused an area to go dead.

Solution: Don't make a judgment until the area has dried completely. Wet, abused paper fibers sometimes will regain their sparkle when they become thoroughly dry. If not, subtle washes can restore vitality. Don't be sparing in the application of the wash. Puddle it on and make sure your paper remains flat during the drying process (if you tilt the paper, the wash will not dry at an even density). Never underestimate the potential of a subtle wash or, for that matter, multiple washes. Not unlike the oil glazes the old masters used, delicate washes can not only enliven an area but add a delicate common denominator hue that consolidates the elements of the picture.

Problem #6: Your painting is complete and reasonably successful, but it needs surface pattern or texture in large light or dark areas.

Solution: In large expanses, texture is usually more effective if it is illusory and suggestive rather than detailed, lest it dominate the more important visual statements. If the area is extremely light, you can add texture only by going darker with small brushstrokes, limited dry brush effects, or even spattering. Also, a suggestion of form to support the texture pattern can be achieved with subtle washes.

If the area is of medium value or density you can go lighter or darker with textural brush work. To lighten a medium density wash, a dampened bristle brush is the tool of choice, but stroke the area with sensitivity and imagination so that vestiges of the original wash remain. Having done this, the application of a few darker accents or dry-brush strokes will usually complete the illusion.

Solutions 2, 5 and 8. I over-detailed the plaid shirt, drawing too much attention away from the facial study. After simplifying the plaid pattern—scrubbing with a large "forgiveness" brush—I sensed that the shirt had lost its vitality. A reapplication of multiple, subtle washes of cadium yellow, ochre and burnt sienna brought the deadened area back to life. I then scrubbed out a few white, vertical highlights in the shirt with a bristle brush to suggest a consistent light source.

THE OLD SALT, 14½″ × 12″, collection of Thom Rivell

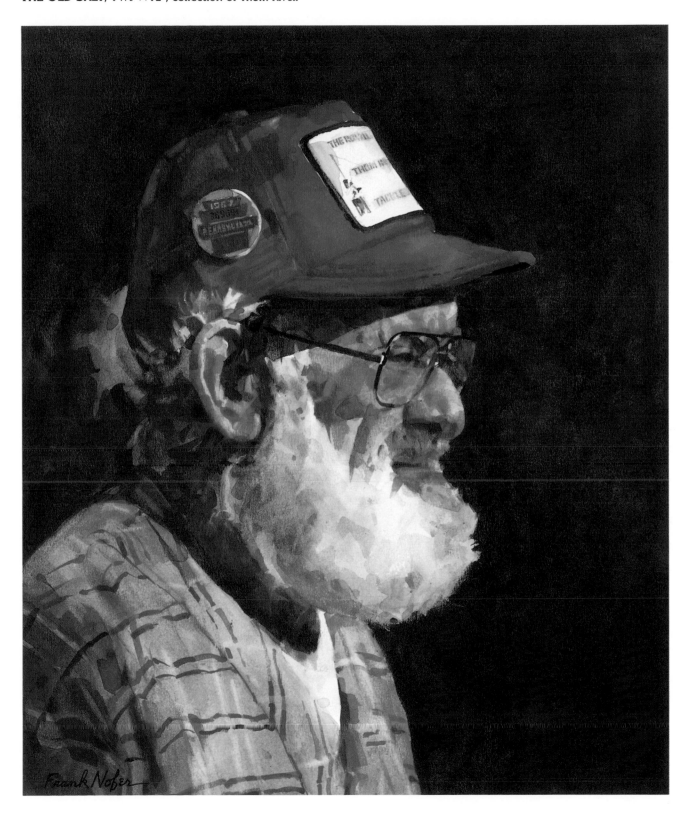

If the lackluster area is black or very dark, it would seem your only alternative would be to go lighter. Wrong! First, a watercolorist should never resort to a pure neutral black. Regardless of how dark the pigment, it should lean ever so slightly in one color direction or another—blue-black, green-black, crimson-black. Therefore, take a dampened bristle brush and partially lift small amounts of pigment out of the darkest areas. While the paper is still damp, apply equally dark paint with the hint of a complementary color to the treated areas and let the edges fuse. For example, if the existing background color is a very dark green-black or blue-black, introduce a very dark crimson-black. Since complementary colors oppose each other, the juxtaposition of the two blacks with their slight difference in color will cause a subtle vibration. This technique is usually sufficient to activate a deadened area, since the eye looks for textural expression in the lighter sections of a painting.

THE STRAIGHT AND NARROW, 10″ × 27″, collection of Mr. and Mrs. William Ferdinand

Problem #7: The entire painting looks "hard" and has overtones of a wood block. Elements appear as silhouettes and edges are too sharp.

Solution: Break or fuse some of the hard edges with a dampened bristle brush. A little bit of this goes a long way in positioning elements *in* the picture rather than *on* it.

Problem #8: Your watercolor is solid in its construction but needs subtle additions, deletions and refinements.

Solution: When moving from light to dark, simply add necessary subtleties by overpainting and introducing detail with small brushes. Overpainting (the laying of additional washes) is not technically a forgiveness technique, but detailing from dark

Solutions 1 and 3. I could have named this painting *Foreboding Foreground*. I used paper towels to blot up four unsuccessful foreground washes and then resorted to the sponge to remove residual pigment almost down to the paper. After allowing sufficient drying time, I laid in a triumphant fifth wash and went on to finish the painting without further problems.

to light (removing paint) requires a forgiving paper surface that can be coaxed into giving up pigment. The sharp corners of a dampened, small, flat-bristled brush can be deftly handled to remove paint in the most sensitive area, such as highlighting an eye in a portrait study or to lighten a larger section. When these lightened areas dry, they will accept delicate additions or corrections as needed.

Hardly newsworthy, but still effective, is the use of razor blades or X-Acto knives to scratch highlights. And an ink eraser can handle the less precise assignments.

Problem #9: The paper surface has been tortured to the point that fibers are raised, all sizing is absent, and the area is blotter-like in its greediness to suck up washes, yet some finishing detail is still required.

Solution: Once the paper has deteriorated to this extent, the washes will flare out and precise detail becomes impossible. You will need to burnish the area with your fingernail or a marble or plastic stylus. Then use a dry-brush approach to control the paint.

Problem #10: You have just experienced "the thrill of victory" when an unnoticed bubble in a beautifully applied wash suddenly results in a very discernible, white bare spot as the paint dries. Any effort to repair the damage by applying a matching wash and attempting to abut the edges almost always results in an overlapping ringworm effect.

Solution: A series of pinpoint dots applied in close proximity will blend the void into the original wash. When implementing this "patch-and-match" technique, use a series of dots which vary ever so slightly in color and value from the background wash. Fuse them gently with a small, dampened bristle brush and when dry, reapply as necessary. A finely pointed red sable brush serves this purpose well. Finally, squint to assure yourself the camouflage will go undetected.

Solutions 4 and 6. The black milk can had become dark, deadly and opaque. I used a large bristle brush to lift pigment and introduced transparent green-blacks, blue-blacks and brown-blacks to regain translucency and still maintain tonal validity. In addition, the light background lacked interest. The addition of texture and a touch of rust added believable patina . . . **Milk Can and Rhodies**, 26″ × 19″, collection of Anne Reimel

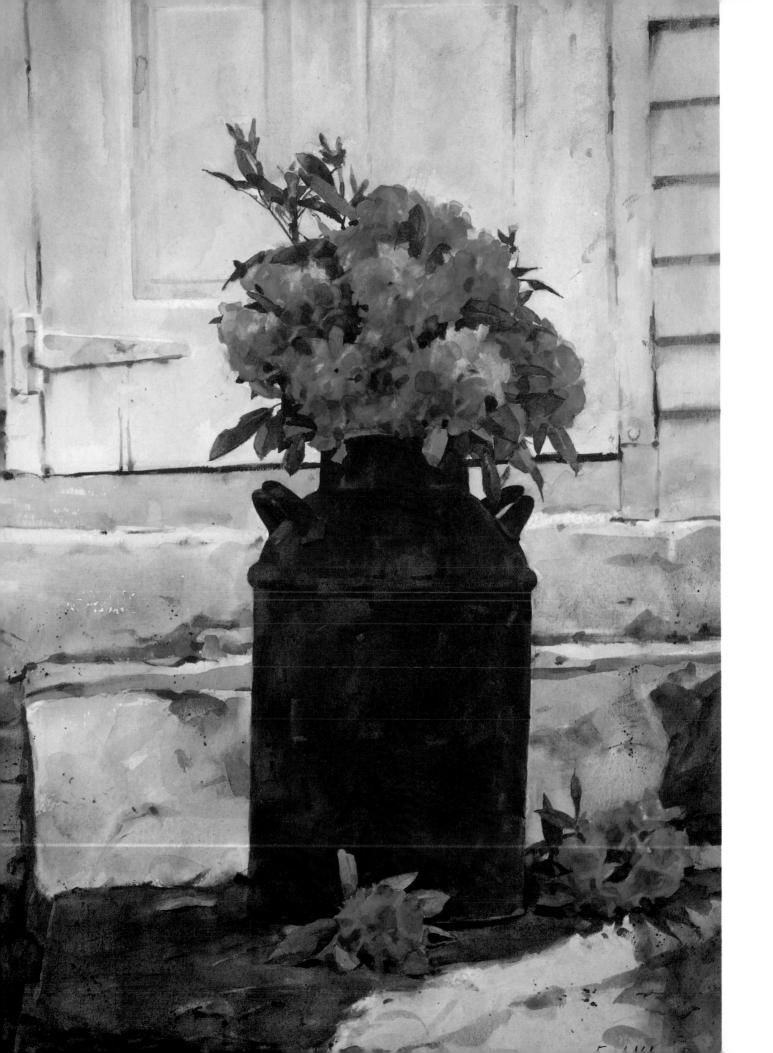

Opaques. You may have noticed that throughout these ten solutions, I did not mention the use of opaques (pure Chinese white pigment or colors made opaque by the addition of white). I don't choose to use opaques because they pop out in a transparent watercolor and can even be spotted in a reproduction of a painting. Nevertheless, some watercolorists use opaques tastefully and in moderation, perhaps to introduce snowflakes or accent details with bright color. The application of opaques is usually based on a final decision that there is no other way to enliven a deadened area. My personal feeling is that in the play of transparent watercolor, opaques, at best, should only assume a cameo role.

The final exam. I took advantage of the full range of forgiveness techniques in painting the watercolors throughout this book. The techniques don't show up as glaring corrections, so forgive me if you must read the captions to determine where each technique was used.

Solution 4. This demonstration shows a dark, dense area in need of relief. A thoroughly wet, flat bristle brush was used to lift excess pigment in the shape of an F symbolizing "Forgiveness."

Solution 3. Hypothetically, at the completion of a seascape, an artist might choose to depict a white gull against a deep blue ocean—without resorting to opaques. In this demonstration, I outlined the gull with masking frisket and then thoroughly scrubbed the bird's shape with a wet bristle brush. After adequate drying time an ink eraser was used to remove pigment practically down to the paper.

Solutions 3 and 9. I prepared this "cardinal transplant" demonstration to prove how forgiving some watercolor papers can be. The cardinal was originally positioned where the white void now exists. I scrubbed out the existing white patch on the right and an identical patch on the left, which I burnished when dry. With slightly dampened transparent color I repainted the cardinal and filled in the background.

Solution 10. The black circle isolates the area in which tiny blue and green dots (a mini-pointillism technique) were used to "patch and match" an irregular white bare spot in the semi-granular background wash. The small square shows an enlargement of this process.

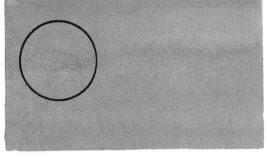

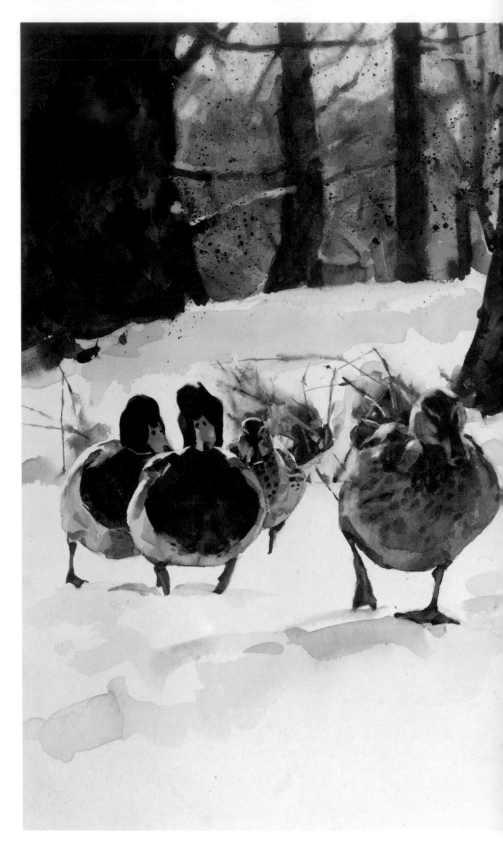

MALLARD BRIGADE, 16½″ × 25″, collection of Edie Gleeson

Solution 2. In painting *Mallard Brigade* I reached a point where the ducks needed more detail or the background needed less. Remembering that "more is usually less," I chose to simplify the background. With a dampened bristle brush I encouraged the hard edges to give way.

Frank Nofer

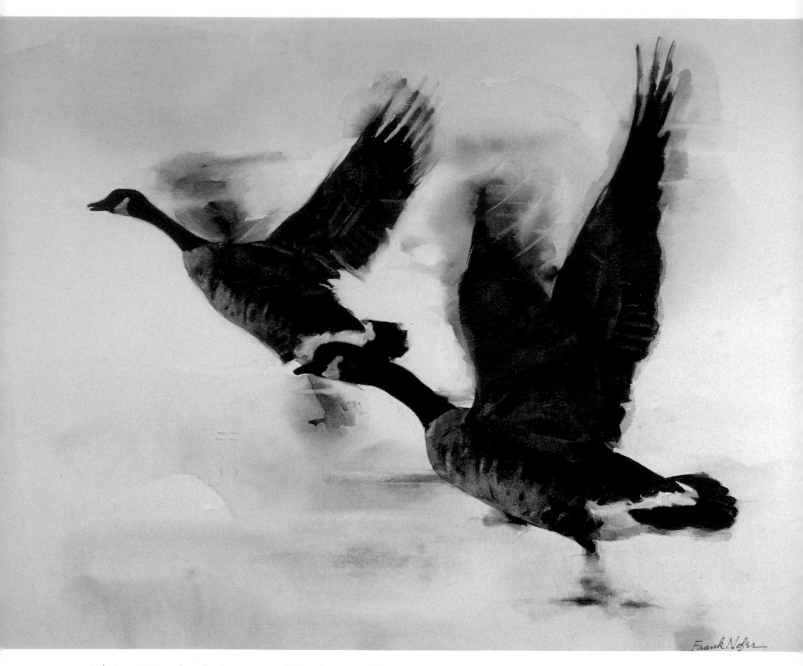

Solution 7. Even though I kept some of the edges wet when I painted these Canada geese, they still appeared frozen in flight. I felt the head and basic anatomy of the birds should remain recognizable, but the beating wings had to be blurred. Since a sponge was too cumbersome, I resorted to small, wet bristles to delicately manipulate selective hard edges.

PART FOUR

PHOTOSKETCHING
Use Photography Creatively

What is Photosketching?

As author of a book on representational, transparent watercolor, I would be wearing blinders if I did not acknowledge that photography now plays an important and controversial role in painting. Regarding the use of photography in conjunction with the development of realistic watercolors, painters fall into four categories:

1. Those who paint only on the spot and, in some cases, frown on those who don't.

2. Those who use a camera but are reluctant to admit it.

3. Those who intelligently employ what I term *photosketching assistance* and make no bones about it.

4. Those who rely entirely on photographs and do their damnedest to duplicate them in paint.

Where do I stand on this matter? My briefest answer is this—

It's no misdemeanor to use a camera, but almost a felony to let the camera use you.

In making an initial judgment regarding photographic assistance there are two basic considerations:

1. If you are a beginning watercolorist you should paint at least fifty or one hundred pictures on the spot (including landscapes, models and still lifes) before touching a camera. The intention of a representational watercolor is to have the viewer react to the subject matter as you did. Especially in outdoor painting, if you haven't spent considerable time "in the field" identifying with the environment, absorbing nature, or experiencing people in action, your paintings will tend to have stage-setting overtones. I don't think it is stretching the imagination to compare the painter who has not served his time on the spot with the soldier who has never been on the front line. Neither can communicate a one-on-one real-life experience.

2. Once you have *on-the-spot tenure* you can evaluate the broadened range of paintable subject matter intelligent photosketching can offer. For instance, painting watercolors on the spot in frigid weather is next to impossible. The question is— will you or your paint-water freeze first? Or, how do you capture a night city scene where office buildings are lighted but your paper is not?

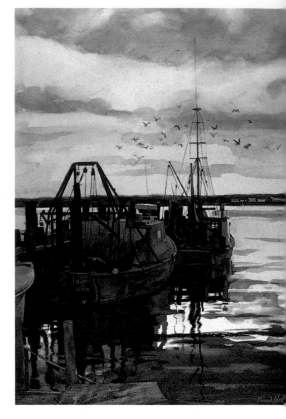

The duration of this dramatic evening lighting condition was about half an hour. Unless I was willing to return evening after evening for a brief painting session, the watercolor would never have been completed. Also, there was no guarantee that the boats would stay put. Hence, to practice the art of the possible, photosketching was the only logical approach . . . **Harbor Sunset**, 20¼″ × 15¾″, courtesy of Newman Galleries

In addressing photography for painters, which is the theme of the next few chapters, my original thought was to touch lightly on the subject. On second consideration, since I have painted many watercolors on the spot and many with photosketching assistance, I realize there is a thin line between proper use and gross abuse of the camera. This is definitely not a book on photography. However, since "a little knowledge can be a dangerous thing," I feel I owe it to the reader to offer my best judgment regarding the introduction of the 35mm camera into the painting modus operandi—and to do so comprehensively. I was concerned that I might leave out some little hint, which could turn the reader into a slave to the photosketching technique rather than a master of it. Hence, as you move through the chapters you will find occasional repetition or re-definition of cogent thoughts which are better emphasized twice than left unsaid. You will also notice there is an overlap of picture-making considerations that are generically applicable to all painting procedures.

Before you start clicking your shutters it is important that we approach the camera with some definite ideas about its role in painting. So let me offer a few guidelines to help frame the camera in the right light.

First, the camera *must* be regarded as a sketching tool. Its basic function is to bring an abundance of visual information into the controlled environment of your studio where it can be perceived, analyzed, re-organized and interpreted. With a camera you can record details and forms that are too elusive to sketch in a real-life situation (just try to sneak up on a deer, for instance). As I mentioned earlier, photosketching can greatly expand your repertoire of subject matter and enhance the vantage points from which you see. Aside from the on-the-spot physical limitations I pointed out, there are other challenges to overcome.

For instance, when you are working on the scene, you must quickly and accurately sketch in the elements of your composition, and be adept at spontaneous paint application to compensate for changing light patterns. Also, it is difficult to re-arrange elements on-site to improve the design of your painting. The ideal vantage point is not always accommodating. And, if you are an on-the-spot painter, you cannot expect humans, wildlife or moving automobiles to pose for you. These are just a few of the disadvantages that intelligent photographic assistance can overcome.

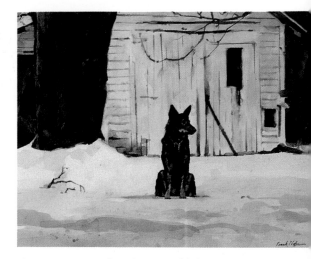

The question was how long would this guard dog endure "cold feet and cold seat" to protect his owner's property. The answer was "not long." Shortly after I snapped a couple of pictures, he headed for warmer quarters . . . **Cold Feet, Cold Seat**, 14″ × 18″, collection of Alfred T. Ogden II

My next important point is this:

Don't take photographs with the idea that you are going to meticulously duplicate them with brush and paint.

Your goal is not to have your friends say, "Gee, your painting looks so real I thought it was a photograph." Remember that photography is *not* the ultimate realism. For instance, it would be a rare photograph that could capture the sense of presence inherent in a John Singer Sargent portrait. The only way a great sense of personal presence and subjective interpretation can be achieved is if you paint the way the human eye perceives.

It bears repeating that with a click of a shutter, the camera completes and records its scene. The human eye, on the other hand, scans and accumulates a series of visual images that it quickly assembles into a total perception. The priority the human eye assigns each miniperception and the pathway it follows in the process of observation can literally "paint" an entirely different picture than that produced by the camera. Admittedly, the camera can do many things our eyes cannot (for instance, a stop-action photo can freeze diver Greg Louganis in mid-air), but it cannot duplicate human vision or paint a personal picture.

One last thought for this chapter:

Avoid the TV Dinner Syndrome. Don't ever use someone else's photographs or sketches as the basis for your work. Always generate your own source material—that's half the battle and half the fun. If you rely on another person's idea for your painting, it's like warming up a TV dinner and taking credit for the recipe.

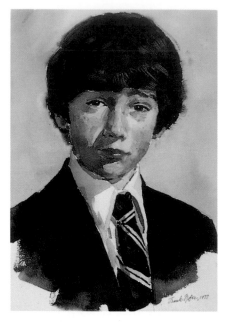

This young lad, the son of good friends, met a tragic death in a swimming accident. I painted his portrait from a series of snapshots provided by his school. For those who insist that photographic assistance is never appropriate in conjunction with painting, this is a perfect rebuttal . . . **Hallie**, 16″ × 11¼″, Mr. and Mrs. Harold Commons

Show me a watercolorist who can paint in 10-degree weather and I'll show you an Eskimo with a heated water jug. I have painted winter landscapes like *February Silhouette* and *Slim Pickin's* from the back of a warm station wagon by the side of the road. In the case of these two watercolors, a good vantage point was not possible from any vehicle. Hence, a quick, on-foot photosketching session provided me with an adequate studio reference.

FEBRUARY SILHOUETTE, 17" × 23", collection of Mr. and Mrs. Ernest Herrmann

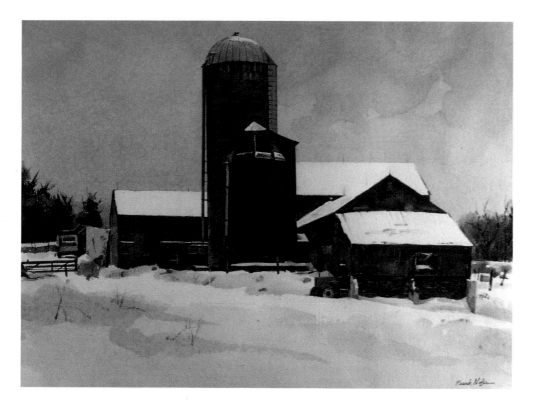

SLIM PICKIN'S, 12" × 18½", private collection

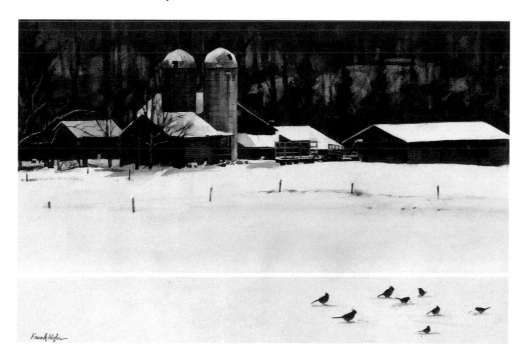

Camera and Film Selection

If you don't already own a camera, here are a few suggestions for equipment basic to photosketching.

A 35mm single-lens reflex (SLR) camera would be my choice. The SLR feature allows you to view your subject, focus, and compose the exact image you see onto film (unlike viewfinder cameras, which have a separate system for viewing). Most cameras have built-in light meters (I wouldn't buy a camera without one), and I prefer the manually operated models over the automatic. I want to make my own subjective decisions regarding shutter speed, lens aperture, and focus rather than rely on the manufacturer's evaluation of what is important in *my* pictures.

A basic 50mm lens is a good selection, since it approximates the perspective of the human eye. This type of lens and others are also available in macro versions for close-up shots (for instance 5 or 6 inches from a bee pollinating a flower). Actually, the 50mm lens will suffice, but you may wish to expand your interpretive photographic capability.

A telephoto lens (approximately 135mm to 200mm) will frequently bring physically unapproachable subject matter, such as distant farm scenes or boats, within photographic reach. The more expensive *zoom telephoto* lenses (such as those which adjust from 80mm to 200mm) obviously permit graduated distance shooting. In general, telephoto lenses are heavier and slower—requiring more light—and the zoom version is a bit more difficult to focus. However, pinpointing specific limited areas of depth of field is a desirable option with these lenses. (Note: Don't be lazy about changing lenses. I recently leaned over a pasture fence to get a "close-up" of a stallion with my 50mm lens; the fence was electrified. A little horse sense would have made it a less shocking experience had I opted for my telephoto.)

CAMERA FUNCTIONS AND TERMINOLOGY

Film speed is indicated by an "ISO" number (formerly "ASA"). The higher the number the faster the film. Unless you match your camera's film speed indicator to the ISO rating of your film, you cannot meter correct exposure.

Lens aperture openings are expressed in f-stops. A typical 50mm lens has f-stops ranging from 1.4 to 16. The f-stop range of a typical 200mm lens is 4.5 to 32. The higher the number of the f-stop, the smaller the aperture opening; hence, a lesser amount of light enters your camera at a given time.

Shutter speeds are pretty much self-explanatory. A shutter speed of 1/1000 simply means that your aperture will allow light to reach the film for that part of a second. Obviously a balance between f-stop and shutter speed is necessary for correct exposure.

However, there is more than one balancing act at your disposal. Assuming that f/8 at 1/1000 is a right exposure, then f/11 at 1/500 or f/16 at 1/250 will also be correct. A smaller aperture at the appropriate speed will afford greater depth of field. A larger aperture at a higher shutter speed will limit critical depth of focus, but offers greater stop-action capability. There are artistic advantages to either approach.

One more tip: Don't try to hand-hold your camera at shutter speeds less than 1/60 (preferably 1/125). If the occasion arises when light conditions require slower exposures, then we're talking tripods, cable releases, separate light meters and a more complicated metering system—a situation usually not encountered in daytime photosketching.

The often-heard term "stop down" simply means to adjust your f-stop to a higher number (smaller aperture opening). "Open up" means the opposite.

"Bracketing" means shooting one photo at the correct exposure, then another which is underexposed, and then one which is overexposed. To underexpose, "stop down" one f-stop from the correct exposure and/or increase shutter speed one increment. To overexpose, do the opposite.

Camera Anatomy

The main features of the 35mm single-lens reflex camera are:
A. Lens
B. Focusing Ring
C. Distance Scale (indicates the camera-to-subject distance in feet and meters)
D. Depth of Field Scale (indicates how much of your subject will be in focus)
E. Lens Aperture Ring (adjusts the f-stops)
F. Shutter Speed Dial
G. ISO/ASA Dial (set this to the film's number when you load your camera)
H. Shutter Button
I. Film Advance Lever
J. Rewind Lever

Wide-angle lenses (28mm), as the name implies, offer the capability of capturing a greater breadth of field than the human eye can see from the same vantage point. Although these lenses distort human perspective somewhat, they are useful when you are faced with insufficient distance between you and your subject. More than one photographer has backed off a pier while striving for an extra foot of shooting space.

Choice of film. Aside from black-and-white, 35mm film comes in color print and slide transparency versions in various speeds. The faster the speed the grainier the picture. Transparency film affords more accurate color reproduction, but requires you to have a projector for painting reference in your studio. For outdoor slide photography, I would suggest Kodachrome ISO 64. For outdoor print film, Kodacolor ISO 100 or 200 are good, and you may wish to experiment with the new Ektar print films. In situations of low-level available light, faster films may be necessary. (For outdoor photography, a polarizer or ultraviolet filter will cut down the glare and haze of intensely bright subject matter.)

An 18 percent gray card is helpful in determining the right exposure for many shots (I'll explain shortly). You can pick up these accurately toned pieces of cardboard at most camera supply stores, but I use the cardboard that comes from the dry cleaners with my shirts—the value seems to be just right.

Finally, a camera neckstrap is mandatory, and it's a good idea to have a camera bag to hold your lenses, film and other equipment. The strap helps keep your hands free to hold, focus, make adjustments, and shoot pictures, and the bag prevents other pieces of equipment (such as your extra lenses) from banging around or falling out of your pocket. It's definitely worth the small investment (fifteen dollars and up).

When it comes to equipment, these suggestions are just the tip of the photographic iceberg. If you are a newcomer to photography, take advantage of every opportunity to review all the catalogs, brochures and primers on the subject. Whenever appropriate, I'll discuss how to operate the 35mm SLR, but it's good to know in detail how and why the mechanisms of your camera function the way they do.

Join Me in the Hunt

Pheasants are on today's menu, and I invite you to join me in the hunt. I'm looking for a series of photos that will detail the color, structure, stance and attitude of these game birds in their own natural way so that I can paint watercolors with pheasants as the main subject.

Pheasants are infrequent visitors to my suburban home, but I do have access to a hunting preserve where pheasants are temporarily penned in a natural surrounding. Even in captivity, these birds, unlike some other species of wildlife, remain wild and become frenzied when humans approach. They literally run around like headless chickens.

But this problem is minor when compounded with the fact that I like to photograph pheasants under snow-blanketed conditions. A colorful pheasant against bright snow plays havoc with your light-meter reading; hence you can end up with useless reference shots that don't give you the visual information you set out to get. Here's the problem: If the human eye focuses on the brightly colored male and ignores the snowy background, the colorful plumage is easily discernible. The camera, on the other hand, will take in all the brilliant light reflected by the snow and will meter accordingly. If you set your exposure (f-stop) and shutter speed according to this meter reading, you will end up with the pheasant as a dark silhouette against a bright background—minimum detail, muted color and flattened form—nothing that you set out to capture. This is a photographic challenge, and here's how I'd go about getting a series of reference shots under these conditions:

1. First, here's where the 18 percent gray card comes in handy. Place the card in the same light plane as your subject matter and take your meter reading *from the card* at a distance of about 18 inches. You'll get a compromised reading, but set your aperture and shutter speed to this reading. The resultant photo will record much of the pheasants' colors, although the snow will probably take on a bluish cast.

To digress for a moment, the gray card technique is very helpful in any situation where there is a great variation in the brilliance or tonal values of the major elements of your subject matter—such as a reflective lake bordered by a dark shoreline landscape against a bright sky. Or in a situation where concentrated, direct-source illumination creates hard cast shadows

Underexposed.

Right on.

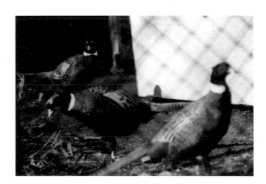

Depth of field problem.

(portraits, still lifes or more expansive compositions), your camera will react more to the black-and-white tonal variations than to the color statements. If you wish to single out a large area of your subject — let's say a mountain, you can isolate your camera focus on that and meter accordingly. However, if you are challenged by a patchwork quilt of darks and lights, a compromise reading from your gray card may more accurately record your visual perception. Remember, a camera can't think — you can!

2. Next, with a 50mm lens I shoot a series of photos with the f-stop wide open (f/1.4) and the fastest correctly metered shutter speed (1/2000-1/500), according to available light. This combination of settings will stop the action and record detail in the birds — but you must achieve critical focus.

3. Then I repeat the process, but with the shutter speed at a slower setting and the f-stop synchronized at a smaller aperture. This will produce greater depth of field, better color saturation and, on occasion, a slight blurring of the pheasants in motion.

4. Because the birds are constantly moving, an ideal on-the-spot composition is a matter of luck. So I focus on one or two birds whose attitude or posturing typifies the species. I am careful to include the elusive and, at times, almost invisible camouflaged hen pheasant.

5. Then, in a more relaxed manner, I photograph pertinent details of the pheasants' habitat — twigs, corn cobs, berry-bearing trees, and the shape and texture of the surrounding terrain, including fence posts, farmhouses, corn and wheat fields, and large areas of brush. I photograph these subjects in both sharp and diffused focus since I'm not sure what visual priority they will assume in my painting.

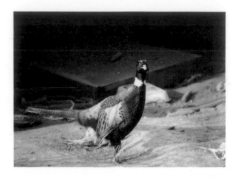

Perfect attitude.

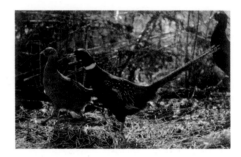

Mood lighting.

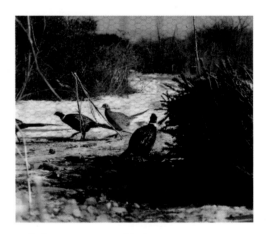

Include environmental habitat.

6. At the same time that I engage in camera exercises one through five, I also bracket every shot. That is, after I get a light meter reading I purposely underexpose and overexpose additional photographs by adjusting the f-stop and/or shutter speed.

7. Finally, I back away and repeat the entire process with a telephoto lens in the hope that my retreat from close proximity to the birds will quiet them down and I can capture them in a more representative attitude of activity. Also, the longer lens allows me to pinpoint a more selective and limited depth of field if I choose to single out a particular bird or other detail. I also include a few ''shoot from the hip'' shots, hoping to stumble into a visual situation that is offbeat, informal and interesting.

In this type of venture I usually shoot several hundred pictures and, as you may have presumed, I'm half frozen at this point. In truth, the shooting is usually concluded when my finger is too numb to press the shutter release. But I'll have spent at least an hour on the scene with my quarry and have gained a better sense of the world of pheasants. If I photosketch pheasants under non-snowy conditions, the process is pretty much the same except the problems of metering to accommodate a reflective snowy background are eliminated.

When the film is developed I analyze all the pictures in my studio and if several rolls of film help me produce two successful pheasant paintings, I consider I've had a good day's hunting. However, without camera assistance my alternative would be to paint *stuffy* pictures of *stuffed* pheasants in a bird museum setting. Not my cup of tea.

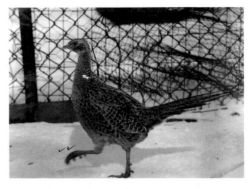

Don't forget the ladies.

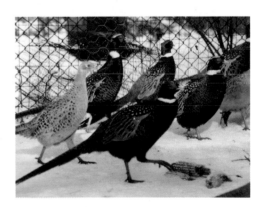

Unnatural grouping—needs editing.

The result of a good day's hunt . . . **Lone Ringneck**, 17″ × 22¾″, courtesy of Newman Galleries

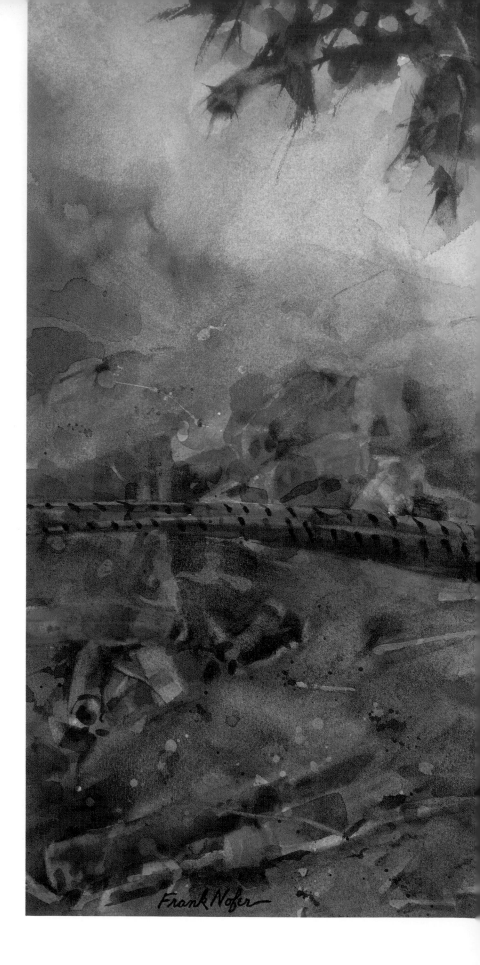

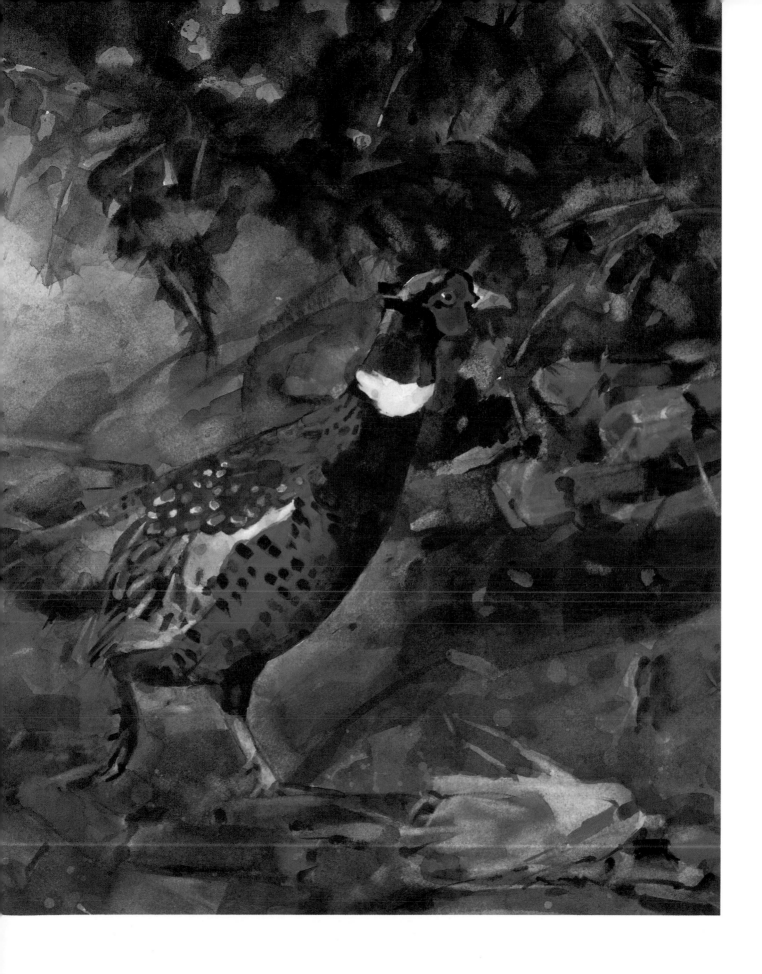

Exploiting Your Camera

I continue to reaffirm that nature offers an abundance of paintable beauty—sunlit forests, snow-blanketed fields, bubbling brooks, and bursting surf, to name a few. And man's creations—towering skyscrapers, bridges, farmhouses and silos, traffic-clogged highways and contemporary shopping malls—also present a wealth of visual themes for the representational painter. While challenging subject matter is bountiful, already-existing, ideal compositions are in short supply.

Frequently, the problem is the appropriate vantage point—finding the position from which the scene offers the best compositional potential. To improve a so-so composition, you may need to change your viewpoint by only a few feet. Other times, a move of hundreds of yards may be necessary. But often the perfect point of view is dangerous, illegal or physically impossible for the painter with palette and easel. The photosketcher, however, can enjoy visitation rights that the encumbered painter cannot have.

But even the best vantage point won't offer the consummate composition. And it shouldn't. Remember, the credo of photosketching is to bring visual reference information into your studio where you can analyze, recompose and interpret it—but certainly not painstakingly duplicate it with brush and paint.

The best way, then, to use photosketching is to open up new possibilities in composition. For example, with a camera, you can stand in the middle of a stream bed and photosketch it—not exactly an easy feat with a set of watercolors. When exploring new vantage points, do so with your senses first. Make firsthand observations of the colors, sounds and how you respond to your surroundings. Then photograph what intrigues you for reference.

Just where can photosketching take you? Here are only a few examples:

Roadside vistas. The danger of attempting to paint from the edge of a major highway is obvious, but carefully pulling off the road for a minute or two of photosketching is safe—I've never been challenged by tractor trailers or state police. Observing the change of seasons from a highway that you frequently travel can spark paintings with a variety of color or a different mood.

Mid-stream. A pair of hip boots and my 35mm camera have allowed me to photosketch waterfalls, riffles and deep blue

The distant vista was great—the vantage point was wet.

pools that heavy shoreline vegetation obliterated, both in winter and in summer.

A different level. Knee- or foot-level views can change the entire attitude of a picture, particularly if you choose to dramatize the foreground by lying on your stomach, as opposed to standing and concentrating on distant subjects.

Detail. Record intricacies of a flower from eight or nine inches away with a macro lens. Such closeness isn't such a safe painting distance if a bee has chosen your flower for pollinating.

Clarity from a distance. I'll repeat what I said earlier that a telephoto lens can close the gap between you and distant, unapproachable subject matter—a boat far out on a lake or a farm scene inaccessible because of a barrier fence.

Breaking with tradition. Not only can you explore new territory with photosketches, but with the help of the camera, you can paint familiar subjects in a nontraditional way. For example, try looking directly upward at closely grouped skyscrapers. You will see steel and concrete converging in the sky. If you're on good terms with your chiropractor, you can lean backward for hours and paint from that vantage point. But for most people, this is a good place to trade paint and easel for a camera. Another interesting vantage point is looking down over your subject. Consider the possibility of painting scenes such as a third-floor, downward view of children in a school playground.

Patterns and elusive subjects. Use your camera to capture patterns made by bridge structures, tree branches against the sky or an upward view of a construction crane. All are ripe subjects for unusual vantage-point photosketching, as are elusive subjects such as small birds. For those, I use secretive vantage points. In winter, I hang two opaque drapes over the inside of the window which is adjacent to my bird feeder. I poke only the camera lens through an opening in the drapes, and cardinals, bluejays and other small birds preen on nearby branches unaware of my presence. This photographic procedure does not truly fit the category of "unorthodox vantage points" because the birds are photographed pretty much from a straight-on point of view, so let's just call it sneaky (but it makes for some great pictures).

Why not move in closer? The sign on the tree and a roaming Doberman pinscher said, "No!"

No, I wasn't napping. A skittish herd of deer in the next meadow suggested an unobtrusive low vantage point.

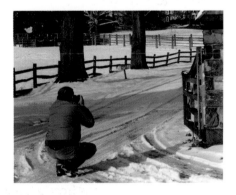

A private driveway limited close visitation rights. A telephoto lens solved the problem.

Don't concoct. But when choosing an unusual vantage point, select one that's believable. In the studio you can improve on it and make it more intriguing, but it must not look concocted. You're an artist, not an acrobat, and for your finished painting to reveal that you had to contort yourself to achieve a certain point of view doesn't enhance your work. The viewer who observes your painting stands in your shoes, and he wants that stance to be a comfortable one.

Absorb yourself in your surroundings. Whenever you are photosketching, completely absorb yourself in identifying with your surroundings. Your personal interpretation as you choose your subject matter will give your work the creative spark. Don't just take random snapshots—always have a concept in mind when you push the shutter release button. But don't confuse photosketching from unusual vantage points with special effects photography. What we're after here is using the camera as a sketching tool to enhance our paintings.

A thorough workout. In all photosketching endeavors, give your subject a good workout. Use a gray card, if necessary, for setting the light meter, bracket your exposures and shutter speeds, and experiment with depth of field (f-stops). Let me remind you of what I said in the previous chapter's pheasant hunt. Don't forget a few shots of details pertinent to your subject. For instance, if you are photographing a forest scene, you may include a squirrel, an interesting leaf formation, or a tree with unusual bark texture. For a seascape, include seagulls and shells on the beach, and if you're creating a farm scene, don't forget livestock, chickens, a tractor or beat-up pitchfork, and always add photos of interesting people to your scrap file.

A cold, encumbered, but effective vantage point.

The center of this intersection provided the best view of the church, but photosketching time was only 45 seconds between red lights.

From Photosketching to Painting

I've shared with you my thoughts on the concepts, principles and techniques of photosketching, but two questions remain:

1. On what basis do you choose between slides or prints?
2. How do you evaluate them in your studio for a concise, well-planned painting?

While many photosketchers work from slides because of their excellent color quality, you may find that prints offer greater flexibility in the planning stages. To make your decision easier, here's a rundown of the pros and cons of both types of photosketches.

Prints. Photographic prints are known commercially as "reflective copy." This means that light must shine on the opaque print and reflect the surface image back to your eyes. Slides, on the other hand, are known as "transparent copy," meaning that light must be projected through them to make the image discernible. Some artists prefer prints because they don't require projectors or other viewing devices to be seen clearly. Here are some other ideas to consider about prints:

Unless you specify otherwise, the prints from 35mm negatives will be approximately 3½×5 inches. Actually, there's slightly more of the image on the longer dimension of your negative than appears on your print. But these prints should be large enough for you to easily determine the success of your photosketching efforts with your naked eye (under normal light).

Multiple prints can be compared and evaluated in one viewing, and the possibilities of combining or eliminating elements are easily seen. You can cut prints apart and superimpose ele-

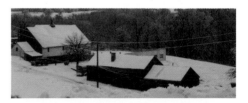

Five experimental variations of the same basic photo print.

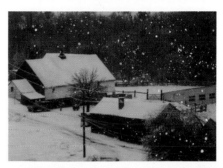

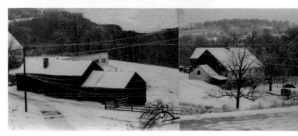

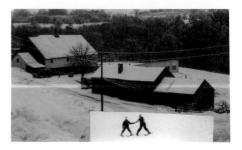

ments, lay scraps of white or colored papers over the prints to simulate snow or eliminate mountains, trees, obtrusive telephone poles, etc. Prints are receptive to opaque tempera, so you can paint in or paint out areas on a trial basis. With care, you can wash off the tempera with minimal discoloration to the print (allow sufficient drying time before trying again). L-shaped croppers work well on prints when making compositional decisions.

No matter how you abuse your 3½ × 5-inch prints while structuring a successful composition, your original negatives remain intact. When you've chosen the prints you want, you may decide to have 8 × 10-inch enlargements made for painting reference. At a somewhat higher cost, a film laboratory can produce 8 × 12-inch prints of the entire negative image. Of course, much larger ones can be made if money burns a hole in your pocket. Frequently, however, 3½ × 5-inch prints are sufficient to inspire a successful painting.

So, in the initial evaluation stage, when you're developing the composition of the painting, prints offer you greater flexibility than slides.

Slides. While reflective copy offers advantages in the planning stages of painting, transparent copy may be easier to work from while actually painting. Here's both the good and bad about slides:

Slides from a 35mm camera are small (roughly 1 × 1¼ inches), and should be viewed under magnification. If you use a projector, you can only evaluate them one at a time. About the only way to achieve group comparison of slides is to place them on a light box and check them out under a magnifying glass or a binocular loupe.

The "one-at-a-time" viewing limitation makes compositional changes more complex—it's not as easy to combine several images. This shortcoming, however, can be overcome. You can make rough mini-sketches or small tracings of the projected images for group evaluation, comparing them against each other as you would with prints. To crop the desired section of a slide, opaque silver tape is helpful.

Assuming you have worked out a promising sketch of your intended painting, there's some good news and bad news about where to go from there. The bad news is threefold:

1. The slides themselves are too small to use as references while painting.

2. Enlarging daylight viewers usually don't provide a satisfactory image to paint from.

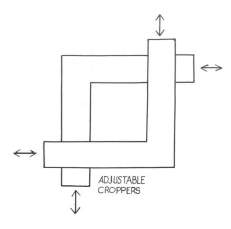

Two L-shaped pieces of white board (croppers) can be shifted back and forth and up and down to evaluate the compositional potential of any visual reference.

3. A projector offers a superb, enlarged slide, but only under low lighting conditions. Since humans don't have cat-like pupils that dilate and contract with tireless and dramatic speed, it's a problem to view the image under low lighting and paint it in a highly illuminated area. Walk out of a darkened theater into an afternoon sun and try to focus. Then imagine doing this hundreds of times and my point is well taken. And the mechanics of devising a studio to accommodate both light and dark is tricky, to say the least.

But the good news is called rear projection. It works like this: You place a special rear-projection slide screen right next to you, under the same light in which you paint. Position your projector on the opposite side of the screen (the greater the distance, the larger the image), and project your slide onto the back surface of the screen. The image reads brightly and clearly on the front surface of the screen. The coating on the rear-projection screen allows the finest contrasts in value, detail and color to show, and you're not distracted by looking into a direct light source.

The following *Questions and Answers* offer more good news on rear projection:

Q. Is a rear-projection screen expensive?

A. Not the smaller sizes—the larger setups become complicated and more costly. An 18×18-inch screen is inexpensive and appropriate.

Q. Do I need a special projector?

A. No, a front projector will work fine.

Q. Isn't there a complete, compact unit (viewer/enlarger) with built-in rear projection?

A. Yes, but they have definite disadvantages.
1. Their scope of enlargement is limited.
2. Most people who use slides already have a good 35mm projector and don't need to pay extra for another, inferior compact model.
3. Some of these complete units weren't designed for long-term viewing and don't have heat dispensing capabilities, so they can damage your slides.

Let me make one thing clear. All you need to purchase is an inexpensive rear-projection screen and perhaps a frame to support it. Use your own 35mm heat dispensing projector (Kodak Carousel or Bell & Howell are good models) to project the image on the rear of the screen.

This is an actual photograph of a fellow artist, Warren Blair, in the process of painting from rear projection screen reference. Notice that his working area is in full light. The projector itself is not visible in the picture because it throws its image on the rear projection screen from a distance of about ten feet.

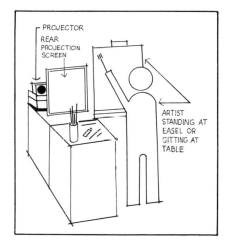

This diagram illustrates the components and arrangement of a rear projection setup. The larger your screen, the larger the image you can project. The distance between the projector and the screen is determined by image size.

Q. Won't the image be reversed?

A. Yes—but if you simply flop your slide, it will read correctly.

Q. Won't my slide melt or become distorted if I leave the projector on for a long time?

A. No, if the projector has a fan blower and a 300-watt (or less) lamp, you can leave the projector in operation indefinitely. But when you turn the projector light off after hours of painting, leave the cooling fan on for 10 minutes—you'll quadruple the life of your bulb. If you are nervous about slide damage, have a duplicate made. This isn't necessary, but may be comforting.

Q. Will my local camera store be familiar with rear-projection screens and have them in stock?

A. Probably no to both questions. You may even be misled. Rear-projection techniques are used mostly in audiovisual presentations, in theatrical backgrounds, and by the few artists who use them, and most camera stores don't handle this trade. Instead of your camera store, look to your local audiovisual dealer. If you still haven't found what you need, you can address your questions to the Da-Lite Screen Company, Inc., Box 137, Warsaw, IN 46580, a manufacturer of a complete line of rear-projection screens. Although Da-Lite does not sell retail, they will provide you with information about available products and a dealer nearest you.

Using your sketches. The initial studio review of prints or slides of your photosketches can be disappointing—you can't seem to find one perfect photo to copy. Good! If you happen to discover a photo that can't be improved upon, then frame it. Don't copy it.

In reviewing your photographic references, discard the losers and try to re-identify with the scene by asking yourself what your on-the-site impressions were and what compelled you to record them. Think of the photos as parts of the actual scene that you brought into the controlled environment of the studio in order to analyze and improve upon.

If you've done your homework, you will have photo references taken with varying depth-of-field focuses and from multiple vantage points. And you'll have shots of other appropriate "extras."

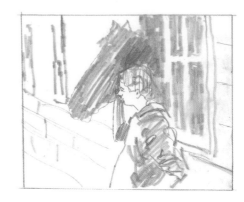

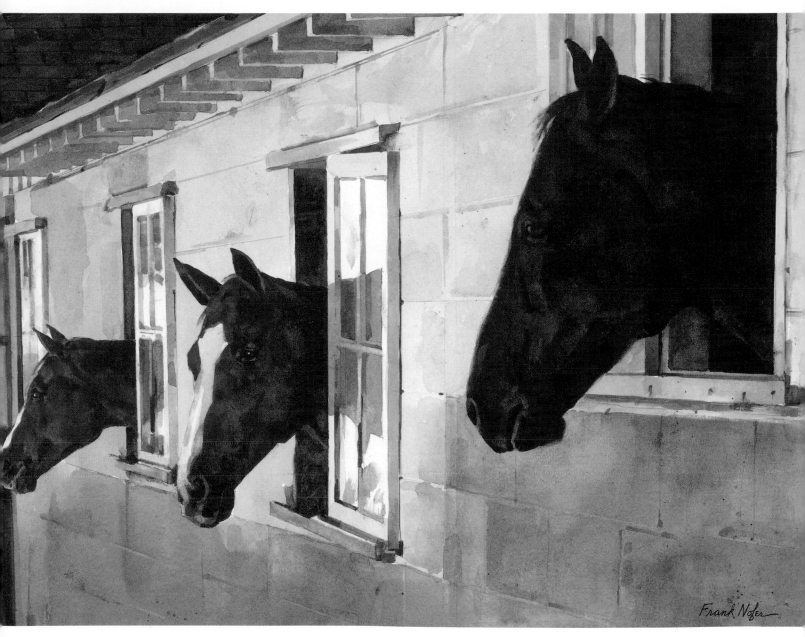

Working in the controlled environment of my studio, I evaluated multiple photos, made pencil sketches of various possible compositions and then painted *Eyeing the Competition*. I was pleased with the results and authorized the watercolor for limited edition prints.

Even after disposing of the photos that have no merit, you will probably still have an abundance of visual aids and that's good. In retrospect you will discover it is always important to be generous in your use of film—if in doubt, shoot. Old-fashioned gunfighters didn't count their shots. They made sure they hit the target, and your attitude should be the same. In nature, ideal compositions are few and far between, and if you struggle over each shot to make it a "winner," you're practicing photography, not photosketching. If you can develop two solid paintings after shooting an entire roll of film, then you can be proud of your marksmanship.

But if you include all of your reference material in your painting, more will probably be less. To select the photos that will form your painting's foundation, first decide on the photo or photos that best communicate your feelings about the scene. Then examine the composition. Use white corner croppers to look for the best arrangement and then adjust elements, if necessary—add more sky, less sky, introduce simplified shadow patterns, textured accents, eliminate obtrusive elements, and so on. Although you're working realistically, strengthen the abstract pattern wherever possible. Then, consider the smaller, enhancing touches. If you've chosen a farm scene, then a cow in mid-meadow or a flock of pigeons circling the farmhouse may add interesting touches that play against the major shapes of your picture.

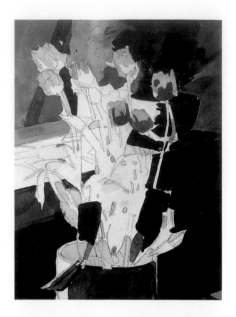

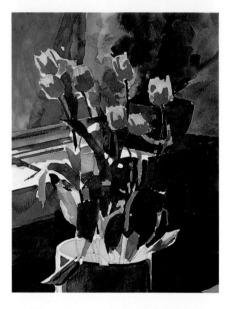

These four reproductions show the progressive painting steps I followed after first conceiving the content and composition of the watercolor. . . . **The Sunseekers**, 17" × 13⅜", collection of Dr. Alfred Beattie

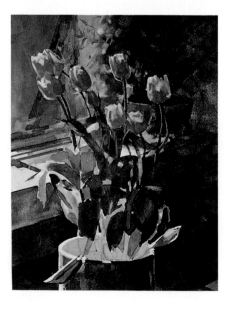

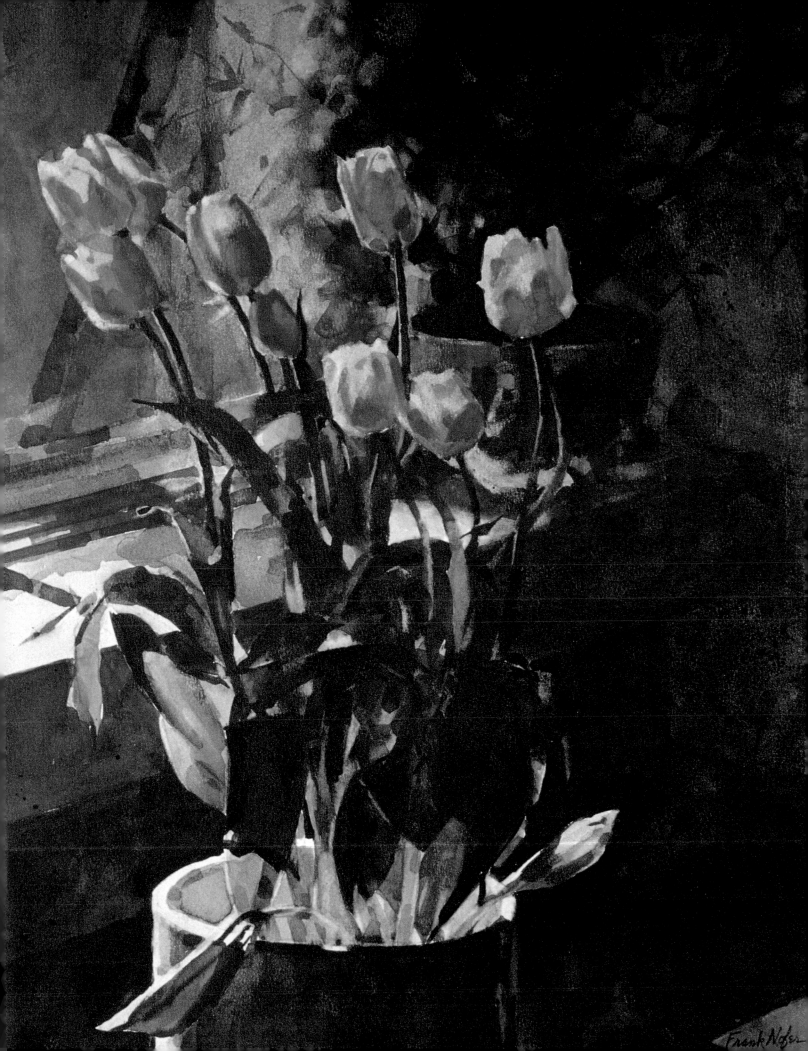

Frank Nofer

When combining elements from different photos, pay close attention to scale, perspective and consistent light source.

A skier, brilliantly lighted from the left, who is standing on a snow-covered slope illuminated from the right is a dead giveaway that you've combined incompatible photosketches. Natural lighting (unless diffused by clouds or haze) provides single-source illumination (there's only one sun). And regardless of subject matter, inconsistently cast shadows will not ring true.

A hazy day with diffused lighting permits introduction or rearrangement of elements without concern for cast shadow inconsistencies.

The major concerns of composition, pattern and texture should be thought out before you begin painting. There's an axiom in carpentry—''measure twice, cut once''—and it applies to the watercolorist as well. Mini-sketches on tracing paper assist in developing your picture, and sometimes larger, comprehensive tracing paper workups are necessary if the painting is complicated. But keep your watercolor paper under lock and key until your plan is resolved. Although paintings can be adjusted, refined and worked over, and even improved in the process, why look for trouble?

A clear, concise painting begins with a good plan, and that's what the right choice of working methods—slides or prints—plus thoughtful evaluation gives you. With these ideas under your belt, you can complete your painting with accuracy and authority.

I usually wash in the dark, light and intermediate colors for the entire painting before starting any refinement procedures. However, in this pheasant study, I wanted to carefully calculate the tonal relationship of the birds to the background, so initially I left them white.

With the background blocked in, I felt less tentative in relating the pheasants to the overall chords of color already established.

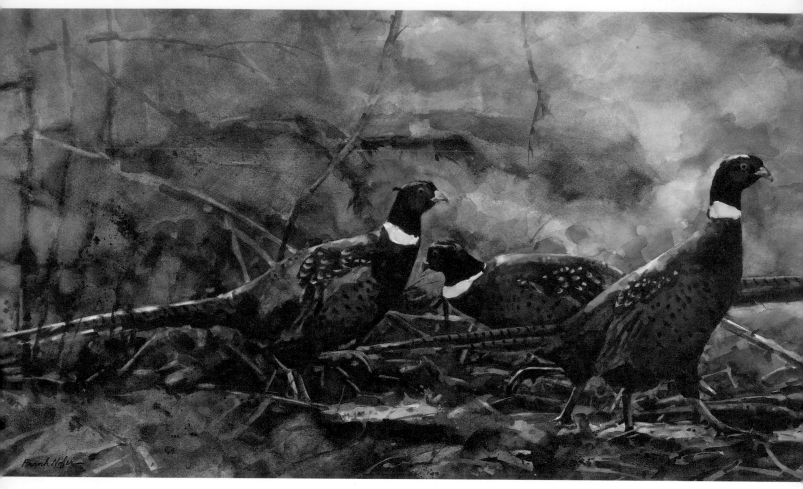

Once I felt this painting was in balance, I needed to concern myself only with the degree of refinement necessary to make it comply with ''how the eye perceives.'' Frankly, I was pleased with the outcome and gave my son the first limited edition print of the painting.

PART FIVE

TEN COMMANDMENTS FOR THE WATERCOLORIST

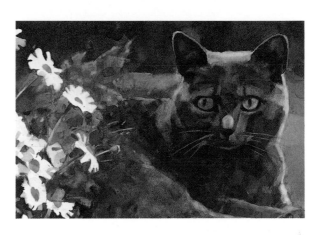

Thou Shalt

1. Remember—talent comes from above, motivation from within.

2. Start with a personalized concept and rely only on your own source material.

3. Not forget that a first-class representational watercolor always embodies sound abstract design.

4. Squint when necessary to simplify your subject matter.

5. Use a camera for reference if you choose—but not let the camera use you.

6. Leave it out when in doubt.

7. Not fall victim to the seduction of technique alone.

8. Not hesitate to work over your watercolor, but not let it appear overworked.

9. Realize that one successful watercolor after another probably means you are not exploring your full potential.

10. Paint your way—only better, and enjoy!

These commandments address our frailties and the temptations we fall victim to in the excitement of painting. I won't pretend they have biblical significance, but if embraced they may prove the salvation of many a watercolor painting.

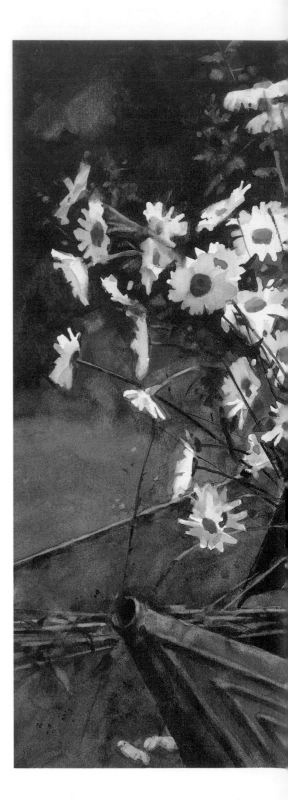

GUARDING THE DAISIES, 18″ × 27½″, collection of Dorothy E. Wise.

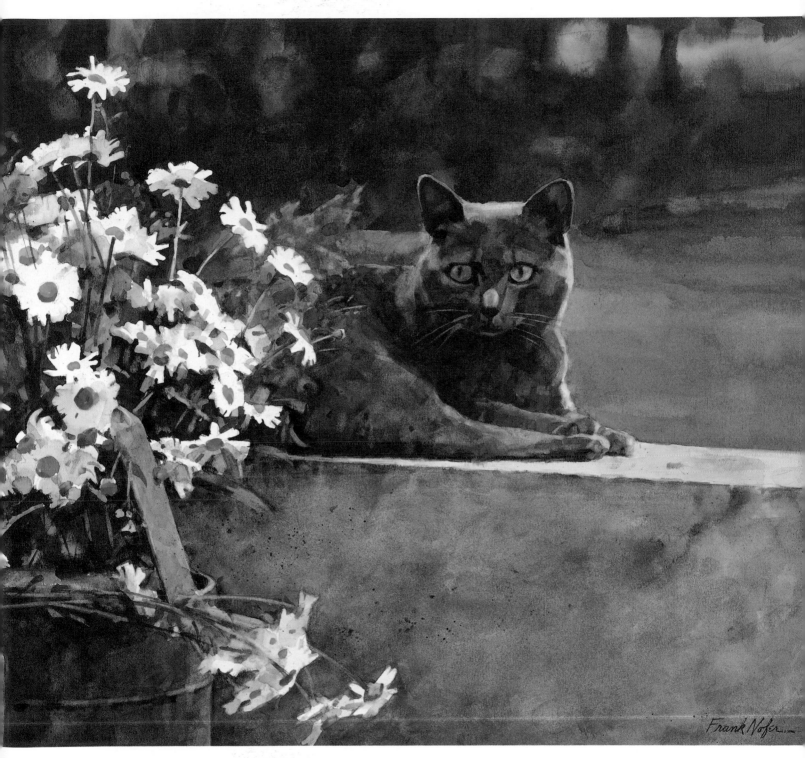

Since I included my brown-and-white cat in a flower still life at the start of this book, I felt obligated to give my Manx cat equal billing.

Summing Up

In the Introduction of this book I invited you to join me in accepting the challenge of watercolor. I hope you took the bait and are now hooked more than ever on reaching your full potential as a representational watercolorist. If the reproductions of my work and my commentary have inspired you to paint with a new-found conviction, then I will feel rewarded that together we have taken a small but important step in advancing the watercolor medium, not only for our own enjoyment, but for those who view our work.

GARDEN BOUQUET, 10¾″ × 17″, collection of Mrs. George Lemmon

A grouping of fresh cut, unarranged flowers can be very appealing.

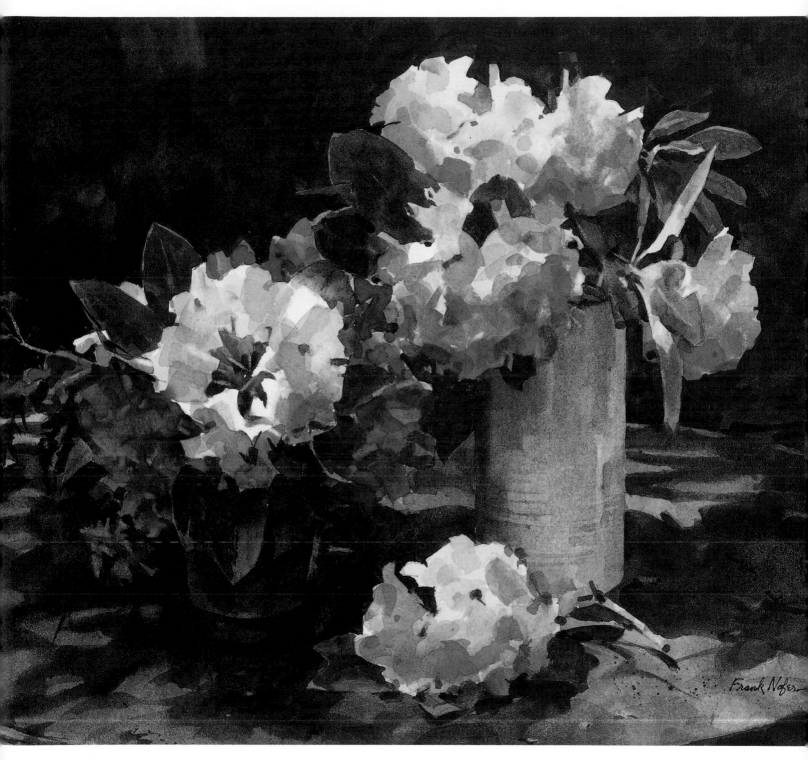

I find rhododendrons are easy to paint if
you quit while you're ahead.

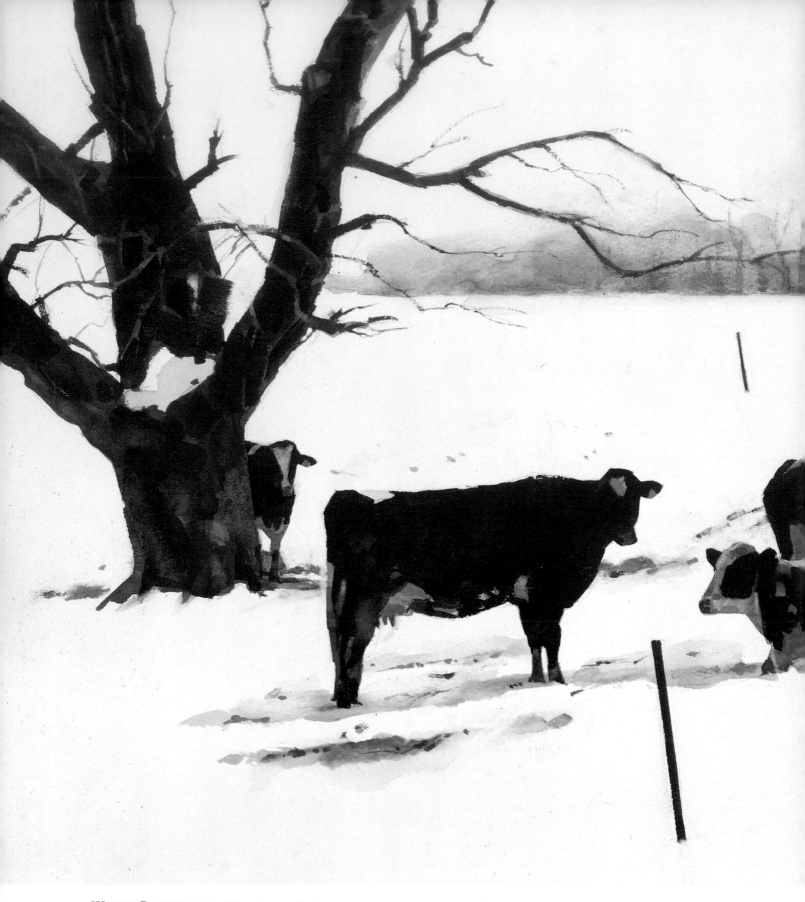

WINTER PASTURE, 15" × 26", private collection

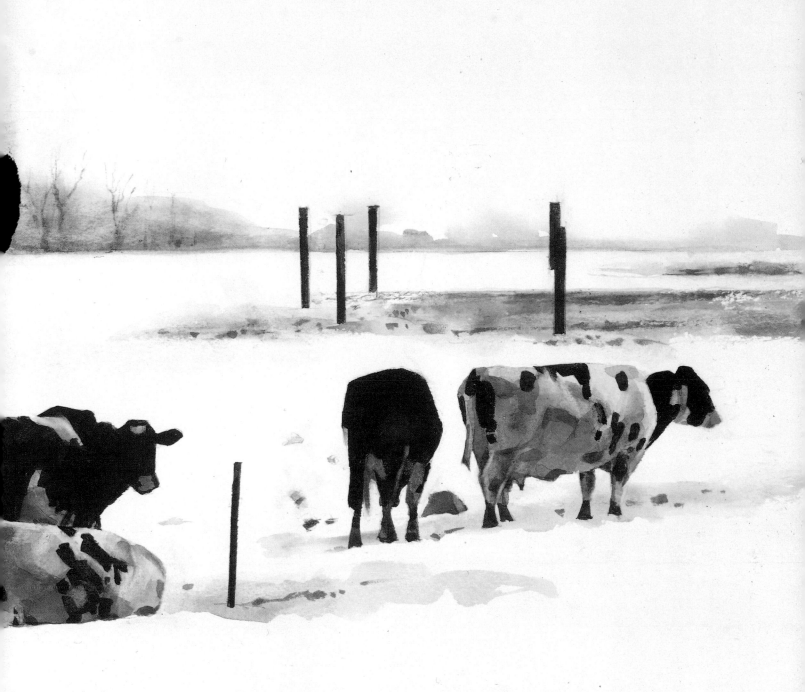

Frank Nofer

Index